INDIANA
INFLUENCE

INDIANA INFLUENCE

·THE GOLDEN AGE OF
INDIANA LANDSCAPE
PAINTING · INDIANA'S
MODERN LEGACY·AN
INAUGURAL EXHIBITION OF THE
FORT WAYNE MUSEUM OF ART
8 APRIL-24 JUNE 1984

Organized by
Independent Curators Incorporated, New York
William H. Gerdts, City University of New York
& Peter Frank, New York City, Curators

ACKNOWLEDGMENTS

The Fort Wayne Museum of Art dedicates Indiana Influence *to the memory of Edith and William Mossman, whose mansion housed the museum from 1950-83.*

This project was made possible with the support of the Indiana Arts Commission, a state agency, the National Endowment for the Arts, and is also supported in part by the Fine Arts Foundation, Fort Wayne, Indiana.

Published on the occasion of an exhibition organized by Independent Curators Incorporated, New York City.

Curators for the exhibition: William H. Gerdts, City University of New York and Peter Frank, New York City.

Supplemental research by Eric R. Kuhne & Associates, Princeton, New Jersey and the Indiana State Library, Indiana Division, Indianapolis.

PHOTOGRAPHIC CREDITS

William Bengston (p. 81)
Geoffrey Clements (pp. 96, 115)
Jane Corbett (pp. 86, 87)
D. James Dee (pp. 98, 99)
Terry Dintenfass, Inc. (p. 97)
eeva-inkeri (pp. 65, 94, 95)
Susan Einstein (pp. 15, 59)
Andy Grundberg (pp. 90, 91)
Indiana State Library (pp. 9, 12, 123)
Phyllis Kind Gallery (p. 80)
Natalie Leimkuhler (p. 43)
Eric Pollitzer (p. 119)
Nathan Rabin (p. 66)
Siegel Contemporary Art, Inc. (pp. 92, 93)
Glenn Steigelman, Inc. Photography (p. 101)
Jerry L. Thompson (p.85)
Steven Tucker (p. 75)
Robert Wallace (pp. 18, 25, 29)

CONTENTS

LENDERS TO THE EXHIBITION

MUSEUMS, GALLERIES,
AND
PRIVATE COLLECTIONS

The American Telephone and
Telegraph Company
Anderson Fine Arts Foundation
Art Association of Richmond
Art Center, Inc., South Bend
Ball State University Art Gallery
The Edward R. Broida Trust
Jay and Ellen Carter Art and
Antiques
Leo Castelli Gallery
Dart Gallery
Sid Deutsch Gallery
Terry Dintenfass Gallery
Mr. & Mrs. Frederick Elbel
Dr. & Mrs. Paul W. Elliot

The First National Bank of
Chicago
Xavier Fourcade Gallery
Allan Frumkin Gallery
Mr. & Mrs. Gordon Gates
Barbara Gladstone Gallery
Greater Lafayette Museum of Art
Blum Helman Gallery
Indianapolis Museum of Art
Indiana State Museum
Indiana State Museum &
Memorials, Nashville
Phyllis Kind Gallery
Adam and Jack Kline
Mr. & Mrs. Clarence W. Long
Mutual Hospital Insurance, Inc.,
Indianapolis
Penny Ogle
Pennsylvania Academy of the
Fine Arts
Max Protetch Gallery
Siegel Contemporary Art
Melvin Simon and Associates,
Inc.
The Snite Museum of Art,
University of Notre Dame
South Bend Public Library
Staempfli Gallery
Mr. & Mrs. Frank R. Stewart
Union League Club of Chicago
Bertha Urdang Gallery
Whitney Museum of American
Art
Mr. & Mrs. Richard E. Wise
Dr. Wally Zollman

ARTISTS

George Deem
John Duff
Mary Beth Edelson
Davi Det Hompson
Jim Huntington
Joan Mathews
Isamu Noguchi
George Rickey
Tom Shelton
Kevin Teare
Tom Young

PATRONS OF THE CATALOG

The National Endowment for the
Arts in Washington, D.C., a
federal agency
Mrs. Ione Auer
Mrs. Betsy Chapman
Dr. & Mrs. John Csicsko
Mr. & Mrs. Lawrence Eberbach
Mrs. Don F. Fackler
Dr. & Mrs. Walter Griest
Ms. Joyce Grotrian
Dr. & Mrs. William Hall
Irmscher & Sons
Mr. & Mrs. Franklin Johnson
Eric R. Kuhne and Associates
Lincoln Printing Corporation
Dr. Stephen and Linda
McMurray
Mr. & Mrs. William McNagny
North American Van Lines
Incorporated
News Sentinel Publishing
Company
Dr. & Mrs. Daniel Paflas
PepsiCo Foundation
Mrs. Jeanne Schouweiler
Mr. & Mrs. Stephen Steckbeck
Jim and Lee Vann
Mr. & Mrs. Michael Walley

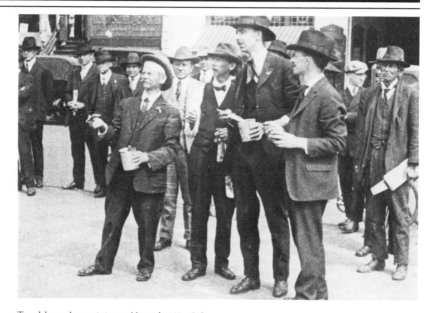

To celebrate the armistice on November 11, 1918, William Forsyth, Otto Stark, Carl Graf, and Clifton Wheeler painted the Liberty Bond Mural for Monument Circle, Indianapolis.

9

FOREWORD

The double exhibition, *Indiana Influence,* commemorates a new beginning in the long history of the Fort Wayne Museum of Art. The historical portion, "The Golden Age of Indiana Landscape Painting," salutes the proud heritage from which this Museum comes: the contemporary portion, "Indiana's Modern Legacy," confirms the knowledge that today's Indiana artists are stronger than ever and deserve museum exposure.

Coincidentally, it was J. Ottis Adams and William Forsyth, whose works appear prominently in the current exhibition of important turn-of-the-century landscape artists of Indiana, who gave impetus to the original art school in Fort Wayne. Adams in 1888, and Forsyth in 1889—their national recognition already well established—came to Fort Wayne weekly to instruct hobbyist painters. In the first two years art instruction took place in a succession of four inadequately equipped, but increasingly larger, studio spaces in the center of Fort Wayne. By then the popularity of the classes prompted Margaret Hamilton to make a gift of the carriage house of her family homestead for the purposes of teaching art and having exhibits. Although Adams and Forsyth were no longer teaching in Fort Wayne in 1897 they had firmly set in motion what was to be known as the Fort Wayne Art School. The Art School had taken hold. Many of its students pursued further training and some even achieved recognition for their work.

When the Hamilton homestead was replaced by a high school in 1903 the Art School raised $3200 by public subscription to purchase a two-story residence in which to continue art instruction. Then, in 1921, Theodore F. Thieme, with equal measures of philanthropy and acumen, presented the community with a dazzling challenge. He would be prepared to give to the existing organization his home, some money and ten paintings as a gift if they could meet certain conditions "which would make Fort Wayne an Art Education Center, providing that artistic development necessary to real progress." His proposal, which began with the declaration that the new organization be called the Fort Wayne Art School and Museum provided the first mention of a museum, as distinct from an exhibition area.

Thieme's timing for the establishment of a museum was perspicacious. In the preface to his proposal he gave an account of current conditions, noting that Fort Wayne's population of 86,000 was quite sufficient to support an "Art Institution" and that "artistic development is more rapid in a city depending on commerce and manufacturing, than in one depending on agriculture." This was followed by Mr. Thieme's cautionary conclusion, that "art schools and museums cannot be conducted without money, and financial support is the best evidence that can be had, either from a community or an individual, as to the amount of interest around." This provocative statement, together with his assertion that he would gladly cooperate with anyone interested in determining if "the time is ripe for putting Art on a solid foundation in our city," was meant to dispel any complacent expectations that he alone would carry the entire burden of funding the Art School and Museum.

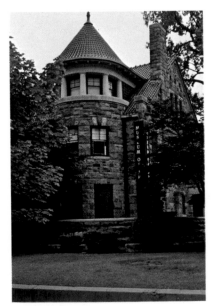

B. Paul Mossman Mansion
Fort Wayne Museum of Art, 1950-83
1202 West Wayne Street
Fort Wayne, Indiana

10

Thieme's demands on those willing to build on his generous offerings specified certain levels of fund-raising and memberships as well as the handling of real property. The offer was received, the challenge was faced, the stipulations were met, and the Fort Wayne Art School and Museum became a reality at the corner of West Berry and Rockhill streets in 1922.

The activities of this new organization fast outgrew the Thieme home so, between 1948 and 1958, four additional houses were acquired to supplement the main building. One of them, the home of B. Paul Mossman at 1202 West Wayne Street was a gift and was used exclusively by the Museum beginning in 1950. During this period the Museum had "exhibitions of its own treasures, as well as traveling exhibitions from other places." Exhibitions and art classes were enhanced by visits from such luminaries in the arts as Edward Weeks, editor of *Atlantic*

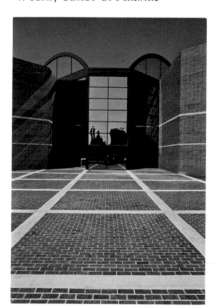

New Fort Wayne Museum of Art, 311 East Main Street at Lafayette, Fort Wayne, Indiana. Walter Netsch, consultant to Skidmore Owings & Merrill of Chicago, Architects.

Monthly; John Taylor Arms, graphic artist; John Canaday, art critic for the *New York Times*; John Mason Brown, drama critic and author; and Norman Cousins, editor and author. These varied public activities underscore the natural melding of several of the arts and also mark the recognition of their importance by the city and the local schools through their annual support.

It was 33 years since Theodore Thieme had provided a home for a separate art museum when Eero Saarinen, architect of Dulles Airport, the St. Louis arch and the chapel and auditorium at MIT, began plans for a new building for an art school and museum. Then Louis I. Kahn submitted ideas for a complex that included the building of a separate art museum. These became the basis for the plans announced by the Fine Arts Foundation in 1964 for the Fine Arts Center.

Apparently the prospect of a new museum building, following years of making the museum's functions fit structures that had been built as private residences, inspired self-study. The purposes of the museum were reviewed and revised; outside advice was asked, considered and mostly disregarded; and goals were written and reversed when their attainment seemed unlikely. During this extended period of questioning the role and aim of the Museum and of experimenting with various objectives, several steadfast themes recur. There has been a firm and consistent belief that the museum was to be "a living force" in the community and that

programs, whose "quality is of the highest order," were to make the museum a "center of activity." Finally, in 1970, after years of discussing What Kind of Museum are We? and coming to some conclusions in the specific areas of the permanent collection, education and exhibits, the general consensus was that the "Museum has to be a progressive idea, for Fort Wayne to fit into."

Thus the philosophical cornerstone was laid by those who were interested in the healthy

11

future of the Museum long before the new building was planned. The building of the Museum's first new home was later accomplished through a broad cooperative community effort that would have pleased the wise Theodore Thieme and that attests to a widely held belief that Fort Wayne needs and wants an art museum that can serve an audience far beyond its boundaries.

In recognition of those 96 years of history and the successes with which the residents of Fort Wayne have met each increasing need and arising challenge, the Museum of Art celebrates the artistic accomplishments, past and present, of Indiana. To Adams and Forsyth, especially, we owe our first beginnings. To all 52 artists represented in the exhibition, we offer gratitude for their special gifts that have become appreciated far beyond the borders of the state that is honoring them. To those artists still working, we share a common bond and an interest in their futures. We hope that they and we can continue to serve the art-loving public.

Valerie V. Braybrooke
Director
Fort Wayne Museum of Art

STATEMENT

When Independent Curators Incorporated was first approached in the Fall of 1982 by Patricia Griest, then President of the Board of Trustees of the Fort Wayne Museum of Art, I was delighted that we were asked to organize the Museum's inaugural exhibition in its handsome new quarters. Since the museum was in a state of transition and the possibilities for an exhibition topic were completely open, it seemed most appropriate to find a subject for the first exhibition which was related to an Indiana subject. Fortunately, two members of ICI's Board of Trustees, Donna Ari, for several years the Director of Education of the Indianapolis Museum of Art, and Jack Boulton, originally from Columbus, have strong ties to

Indiana, and were extremely enthusiastic and supportive in our quest for the appropriate theme. After much discussion with them and Patricia Griest, and research on the part of ICI's staff, we learned that Indiana has given impetus to an extraordinary number of important artists, many of whom are now helping to form the spirit of contemporary art in this country and abroad, and others, no longer alive, who have been major creative forces nationally and internationally. Since ICI specializes in creating exhibitions of contemporary art, it was the wealth of artists active since the 1940s with strong ties to Indiana which first caught our collective imagination. Also of significance, however, is a cohesive group of Indiana landscape artists who worked in the state during the late nineteenth and early twentieth centuries. Thus, it seemed

Painters from all over the Midwest converged on Brown County, creating one of the first art colonies.
Front row — Homer Davisson, L.O. Griffith, V.J. Cariani, C. Curry Bohm, Charles Dahlgren, George Mock
Second row — Edward K. Williams, Ada Walter Shulz, Musette Stoddard, Marie Goth, Lucie Hartrath, Robert Root, Adolph Robert Shulz
Third row — Will Vawter, Paul Sargent, Carl Graf

12

important to bring the inaugural exhibition into focus with highlights of both of these moments in time, without concern for precedents, or links between them.

Indiana Influence contains as mentioned above, two separate and distinct exhibitions which share Indiana roots, although separated by time and the shift in creative imagination which has changed our perception of art as we have moved through this century. In the earlier section, we see work by artists who were primarily motivated to explore and record aspects of the physical beauty of the landscape in which they lived; in the contemporary section, the "landscape" under consideration is more one of the mind.

What is it about the State of Indiana that has caused it to produce (or touch the lives of) so many artists? Although I have no answer, the organization of this inaugural exhibition has caused me to pose the question many times, since by creating this exhibition we have not only remembered that William Merritt Chase came from Indiana, but have come upon equally fascinating information about other Hoosiers active in the arts. Among those past and present related to the State of Indiana are composers, musicians, or vocalists such as Hoagy Carmichael, Cole Porter, Margaret Hillis, John Eaton, Michael Jackson, Crystal Gayle, and George Shirley; comedian David Letterman and authors such as Janet Flanner, Kurt Vonnegut Jr., and Jessamyn West; architect Michael Graves; and fashion designers Norman

Norell, Halston and Bill Blass, not to mention other contemporary artists whose work, for lack of space, is not able to be shown in *Indiana Influence* Certainly this exhibition celebrates the wealth of artistic spirit which springs from the place and people of Indiana, as well as the new museum building.

I am particularly grateful to the extremely able curators, Dr. William H. Gerdts and Peter Frank, for their diligent research, for their eagerness to preview the many works of art from which each selected objects for the separate sections of this large, two-part exhibition, and for the promptness with which they completed their share of the work on this project. Special thanks are due Robert Yassin, Director of the Indianapolis Museum of Art for his early encouragement, and for the incursions we made into that museum's files. ICI's staff contributed significantly to the final form of the inaugural exhibition: in particular, I would like to thank Mike Harwig for the expert manner in which he located many of the specific objects for the exhibition and Elisabeth Hahn for her attention to the myriad details necessary to finally bring the work together in Fort Wayne. On behalf of Dr. Gerdts, I would also like to thank Ann B. Abid, Martha Blocker, Ellen W. Lee, Susan J. Dickey, Dean A. Porter, Ruth B. Mills, Alain Joyaux, B. D. Weddle, Judy Oberhausen, Jane and Henry Eckert, and his wife Abigail.

All the lenders to this exhibition *Indiana Influence* from many disparate points—from Maine to New Orleans, from Philadelphia to Chicago, as well as those in Indiana itself—are due our gratitude for their generosity; without them and their enthusiasm for the exhibition, it would have been impossible to bring together these excellent works of art. Most of all we are indebted to each of the artists who have joined together here to celebrate this important new endeavor on the part of the Fort Wayne community.

Susan Sollins
Executive Director
Independent Curators
Incorporated, New York
February 1984

13

One of the most interesting and rewarding occurrences of recent years, in regard to our understanding of our cultural heritage, has been the awakening and growth of interest in regional developments. There has occurred a broadening of understanding and appreciation of aspects of creativity beyond the more familiar chronicles of the cultural history of the Northeast or abroad. This is not meant to suggest, let alone call for, any

THE GOLDEN AGE OF INDIANA LANDSCAPE PAINTING

form of revisionism, for during at least the eighteenth, nineteenth and early twentieth centuries the fires of innovation in literature, music and the visual arts were kindled primarily in Boston, New York and Philadelphia, and their environs. Or, as in some cases, the sparks were ignited abroad among eager spirits who had journeyed from the American centers in the hopes of inspiration. At last we are becoming ever more aware that the vast expanse of the continent beyond those centers was hardly a desert, or if it were, there were powerful forces at work which could show the "desert blooming like the rose," as one writer put it in December 1894, when commenting on the seminal exhibition of Indiana landscape in Chicago.[1]

The study of such regional developments in the arts of our country seems to have lagged behind those in the field of literature. We are considerably more aware of the literature produced in and reflective of life in the Middle West at the turn of the century, or in the South in the early decades of this century, than we are of the art produced in those regions at those times. *The Shepherd of the Hills*, for instance, had more national recognition than the work of any artist of The Society of Ozark Painters. Even today, James Whitcomb Riley remains a strong national figure in our literary history, while his good friend and portraitist, Theodore Steele, is still faintly known beyond the borders of his native Indiana.

It may be that such literary developments were more independent, more original, than their corresponding artistic manifestations. Harold Bell Wright, author of *The Shepherd of the Hills*, and Riley, together with Hamlin Garland and William Faulkner, are recognized as having developed unique voices, while Steele's art was thought to have had a general vision which was part of a broad scope of American artistic developments. American art, at that time, was a manifestation of its involvement with the Munich aesthetic or

with a somewhat tempered Impressionism which found favor throughout the United States. Yet, even if it were true that the greater part of regional art mimicked developments occurring in the large, traditional metropolitan centers, this is not sufficient reason to ignore it if its quality was superior. Some regional American art is truly original, and some—the genre paintings of St. Louis' George Caleb Bingham and Pittsburgh's David Blythe, or the Bayou

communication that enabled cultural innovations to become known rapidly and be assimilated in sophisticated centers. Furthermore, those regional centers often became both self-conscious and self-assured in their cultural ambitions; they not only imported art, artists and lecturers to their communities, they also set up cultural centers, art schools and exhibiting organizations in an attempt to satisfy local imperatives, and sometimes even to compete with

at the end of the nineteenth century that American art was no longer the art of a provincial cultural outpost but could be as accomplished and sophisticated as the art of Europe, as accomplished as the painting and sculpture produced in Paris and Munich. It was in these European capitals that young Americans were studying and competing for places and prizes in the great annual exhibitions.

There was a danger, of course, that in such cosmopolitan

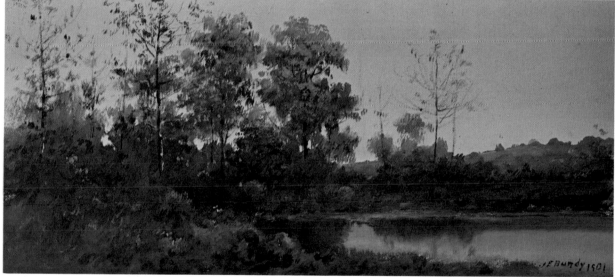

landscapes of Joseph Rusling Meeker—have been recognized by our cultural historians.

Regional artistic developments in this country came to a head at the end of the nineteenth century and the early decades of the twentieth, which is the period covered in the historical section of the exhibition, *Indiana Influence*. That time period saw a conjunction of growth in the larger urban centers of the Midwest, the South and the West with improvements in transportation and

those of the established Eastern centers. Louisville, Kentucky, for instance, ran art exhibitions annually for a decade and a half from 1872 and the Carnegie Internationals began in Pittsburgh in the mid-1890s.

The Pittsburgh exhibitions, as their name indicates, reflected the new cosmopolitan interests in American art. They sounded the note of triumphant self assurance

achievement, the "Americanness" of the nation's art would be lost. Some of the ablest critics of the period, such as William Crary Brownell, actually lauded the loss of the distinctive "characterlessness" of what passed for American art, and praised the young artists who were "beginning to paint as others paint."[2] Other critics, however, were disturbed by the imitativeness of American painting in the last decades of the nineteenth century, particularly when it was viewed in an

John Elwood Bundy
LANDSCAPE, 1901
Watercolor and pastel on board, 4½ x 10⅙ in.
Fort Wayne Museum of Art

international context in the great Universal Expositions and the World Fairs of the period. Foreign reviewers—particularly the French—echoed those charges of imitation, judging the Americans as either having learned their foreign lessons well, or practicing them poorly. American critics, art lovers and artists disturbed by those allegations, sought some solution by which American cultural manifestations would not return to a bygone provinciality, but would ally their newly achieved modernity to a vision uniquely American. This, however, seemed less likely to occur in the long-Europeanized eastern Metropoli, and some writers found inspiration for such a national expression in the American heartland, in Hoosier country.

THE SEARCH

for an American form of modernism was not only a desiderata of some of the critics of the late nineteenth century, it was perceived as a goal among some of the Midwestern artists, and the general concerns probably became clear before they realized that the form it was going to take lay primarily in their interpretation of landscape. In the East, landscape painting constituted the first native artistic manifestation, when the Hudson River School emerged in the second quarter of the nineteenth century to celebrate the glorious American landscape.

Although that aesthetic was exported to the Far West and even to South America, by Albert Bierstadt and Frederic Church respectively, the Midwest offered nothing of the grandeur of the Rockies or the Andes to inspire comparable pictorial adulation in either native artists or visiting easterners. Rather, the Midwest provided inspiration for the presentation of folkways for the most original of the native painters such as Bingham and Blythe, while the great majority of local painters fell back on the most traditional form of painting, portraiture. This was also, until the final decades of the nineteenth century, the only practical and economic course for an artist to take, for portraits were almost always painted on commission; the artist knew that the portrait was desired before he began his work, and therefore was assured payment for it, at least if it met approval. Other thematic forms were speculative, and without a regular exhibition or marketplace, reliance on the production of landscapes, genre pictures or still lifes was entirely problematic. Barton Hays was one of the most eminent Indiana portraitists of the third quarter of the century, and was the teacher of William Merritt Chase and John Washington Love. He worked primarily in Indianapolis where he was also an able still-life specialist, but he could not have made a living by pursuing that theme alone.

Likewise, while occasional Indiana landscapes were painted by the amateur artist during the first three quarters of the nineteenth century, few professional artists indulged regularly in this theme, with the exception of the production of travelling panoramas by artists such as Marcus Mote. Hays painted a few landscapes, and it was a theme undertaken by Indiana's other two best-known early painters, George Winter and Jacob Cox, as well as less well-known painters such as Peter Reed and Thomas Glessing. Glessing was probably the earliest landscape specialist in the state, although part of his livelihood depended upon his employment in creating stage scenery for the Metropolitan Theater in Indianapolis.[3]

Prominence in the celebration of the Indiana landscape begins in the 1880s, with the emergence of the artists of The Hoosier Group and their contemporaries in Richmond, Indiana. The one significant exception was William McKendree Snyder (1849-1930). Snyder was born in Liberty, Indiana but moved at an early age to Madison, on the Ohio River, which is the community and landscape with which he is associated. Snyder's landscapes have a specificity and detail that would rank him as the Indiana painter to share most closely the aesthetic of the Hudson River School. He is supposed to have studied in the East with a number of the later artists trained in that aesthetic, after having worked with John Insco Williams in Cincinnati in the late 1860s. Between those two locales, he lived briefly in Columbus, Indiana and is said to have painted in nearby Brown

County at the time, making him the first professional landscapist to explore Indiana's most pictorialized scenery, and establishing a link between Snyder and the artists of the great period of Indiana landscape. Most of Snyder's landscapes, however, were painted around his home territory of Madison where he favored the autumnal beechwoods (fig. 1) rendered with a sense of mood and drama unknown to the occasional landscape painters of previous generations in the state.[4]

Although seminal developments in Indiana landscape painting took place away from the Ohio River valley, the leading painters of the genre did not totally avoid the region. In 1892, Theodore Steele painted one of the most panoramic of his canvases depicting the Ohio River valley from the campus of Hanover College in Hanover, Indiana. It was a work

commissioned by his friend, John H. Holliday, whose portrait Steele also painted.[5]

THE EMERGENCE

of the great age of Indiana landscape painting, including Steele's work, can be localized in Indianapolis and ascribed to the developments that occurred there in the mid-1870s. Actually, artistic achievements were publicly recognized as early as 1852, with the establishment of the first State Fair. The exhibit the following year included a number of landscape artists, including Jacob Cox. The question of an Academy of Arts for Indianapolis arose in 1853, and three years later the Indianapolis Art Society came into existence for the purpose of raffling works of art.[6]

Major cultural stimulus for the promotion of the fine arts in Indianapolis, as in many other communities, seems to have derived from the activities

connected with the Centennial Exposition held in Philadelphia in 1876. Articles on the fine arts began to appear in local newspapers, and lectures began to be presented on aspects of the arts. At the same time, and of greater significance, artists began returning from study abroad, revealing to the public their more sophisticated training and proselytizing for the proper education of those who aspired to be artists. One such painter was John Love, who had grown up in Indianapolis and studied there with Hays, before going to Cincinnati where he worked with Henry Mosler. In 1872 he went to New York where he studied at the National Academy of Design before going to France where he studied at the Ecole des Beaux-Arts in Paris and with the great academician, Jean-Léon Gérôme. He exhibited several times at the Paris Salon and spent time at the French artists' colonies at Barbizon and at Pont-Aven. Love was one of the earliest Indiana artists to enter into the new cosmopolitan art world opened up for Americans in the post-Civil War era. He was a friend of such noted Americans working abroad as Will Low, Henry Bacon and Daniel Ridgway Knight.[7]

Love returned to Indianapolis in 1876. Almost immediately he led the formation of the Indiana

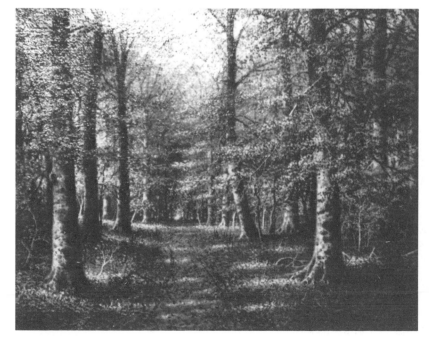

1 William M. Snyder
AUTUMN BEECHES, n.d.
Oil on canvas, 16¼ × 15¼
Adam and Jack Kline

17

Art Association in 1877 which held the first regular art exhibition in its gallery in the Bates Block that January. In July the Association began to extend their activities when Love was joined by James F. Gookins, who had returned to Indianapolis in 1873 from training in Munich to issue a prospectus on a state school of design. It opened its doors as the Indiana School of Art on October 15 in the Fletcher and Sharpe Block.[8] In addition to operating an art school, the Indiana Art Association held a major show, the "First Quarterly Exhibition" in May 1878.[9] Despite swift beginnings the Indiana School of Art had only a brief existence. Gookins and Love, trained respectively in Munich and Paris, disagreed on artistic matters. Gookins, the

18

2 John W. Love
THE SYCAMORES, 1878
Oil on canvas, 29½ × 24½ in.
Indianapolis Museum of Art

Director, left soon after the May exhibition for Terre Haute and then Chicago. Assistant Director Love continued for one more season but closed the school in 1879 and died soon after.

Yet the activities of the two men in these few years of the later 1870s in Indianapolis were extremely influential, and their inspiration carried on to the founding of the Art Association of Indianapolis in 1883. Munich-trained Gookins, who taught painting at the School of Art undoubtedly influenced several of the key artists of the next generation, some of whom studied with him, to pursue their studies in Munich. Love, who taught drawing, was far more exacting in his teaching and manner as he was the more dedicated of the two to his art. His landscape work, such as *The Sycamores* (fig. 2) painted in 1878 at the time of his closest contact with the young men of the next generation, may have imparted inspiration for the poetic possibilities of landscape painting. Certainly Love was not forgotten: James Whitcomb Riley wrote a memorial poem to him, and in 1894 the Portfolio Club of Indianapolis held an exhibition of his work. More significant is the fact that the younger Indiana painters continued to acknowledge that they owed their introduction to modern art to Love and Gookins.[10]

HOWEVER brief the duration of the Indiana School of Art, it was there that Hoosier painting began moving toward a participation in late nineteenth century cosmopolitanism and modernism. Associated with the Indianapolis Art Association was Theodore Steele. Steele was destined to become the most significant figure in Indiana art in the late nineteenth and early twentieth century, not only as the dominant figure in The Hoosier Group and the one to achieve a national reputation, but later in his career as the leader in the movement to Brown County which was a prime stimulus for the art that developed in Indiana during the succeeding generation.[11] Steele was born near Gosport in Owen County, but grew up in Waveland, and entered the Waveland Collegiate Institute in 1859 where his artistic interests developed. After graduating in 1868, he studied art briefly in Chicago and Cincinnati where he learned by copying portraits by Gilbert Stuart and Sir Thomas Lawrence. By 1870 he was a professional portraitist, working for three years in Battle Creek, Michigan before returning to Indiana.[12] Settling in Indianapolis, Steele gained the attention and support of Herman Lieber, who ran the principal art supply emporium there. Steele's work began to be seen extensively at Lieber's, in the Indiana State Fairs, and in the exhibitions related to the active, if short-lived Art Association. In 1880, influenced by Love's and especially Gookin's foreign training and experience, and supported by Lieber's patronage, Steele departed for study in Munich.

He was not alone. Steele and his family were joined by other Indiana artists: Samuel Richards and his wife, the engraver August Metzner, Carrie Wolff and, most important for future Indiana developments, J. Ottis Adams, born in Amity, Indiana. Adams had previously studied at the South Kensington art school in London from 1871-73 and had settled in Muncie in 1876 on his return to Indiana.[13] This Indiana group in Munich was joined in 1883 by William Forsyth, who had studied with Love and Gookins at the Indiana School of Art. Forsyth's *Art in Indiana,* published in 1916, was drawn from a series of 15 articles he wrote for the *Indianapolis News,* and constitutes probably the most incisive history of these early, crucial years in Hoosier art. In it he discusses the reasons these painters chose to study in Munich rather than in Paris which, by the early 1880s, had surpassed Munich as the premier foreign center for Americans studying art. Forsyth mentioned the inexpensive cost of living, and the ease of access to the Royal Academy in Munich compared to that of the Ecole des Beaux-Arts in Paris; he also noted familiarity of the German language among many of the Indiana art students, and above all, the reputations already attained by artists such as Frank Duveneck and William Merritt Chase who had

previously studied in Munich. Artists from German-American communities, particularly those beyond the east coast and especially in Midwestern communities such as Cincinnati and Indianapolis as well as San Francisco, seemed to heed the call to return to a sympathetic environment in Germany. Gookins, the one who offered immediate precedent, and William Merritt Chase, the most famous of Indiana-born artists, were role models. It is also significant that Adams was first stirred artistically by viewing Chase's paintings at the Indiana State Fair in 1869; and Forsyth was influenced by Chase's works in the Indianapolis studio of Chase's first teacher, Barton Hays.

In 1880 modernism in art was upheld in New York City by the new, vital organization, The Society of American Artists, founded only three years earlier. In the early exhibitions of the Society, critics noted a prevalence of the aesthetic of Munich with Chase as its leader.[14] The significance of Munich was also underscored in the writing of Samuel Benjamin, one of the leading critics and historians of the period, whose articles in *Scribner's Monthly* of 1879 were brought together the following year in his book, *Art in America.*

Steele returned from Munich in 1885; Adams remained until 1887; Forsyth stayed until 1888. All three were diligent and perceptive students and were involved with the important social and artistic organization, the American Artists' Club. The academic training to which the young Indiana artists submitted was not drastically dissimilar to

that of their Parisian colleagues, though Munich favored greater emphasis upon character studies and perhaps less upon the depiction of the nude. Steele, Adams and Forsyth studied drawing with Gyula Benczur, and Forsyth also with Nicholas Gysis; all three then went on to study painting with Ludwig Loefftz, a friend and former art student colleague of Frank Duveneck, who was considered the finest teacher in the Munich Royal Academy at the time.[15]

Munich was important as a training ground for these and other Indianapolis painters, but more than craftsmanship developed there. Forsyth documents the inspiration gained in Munich at the great international expositions held biannually in the Glasspalast where the artists and public had the opportunity to see the art from different nations in Europe.

"It was noticed above everything else that it did not matter in what school the artists were originally trained, whether at Paris or Munich or elsewhere, on returning to their native land they invariably took on the characteristics of the people from whom they sprang, thus making their art a national one. This was especially noticeable in the small nationalities, such as Holland, Sweden and Norway . . . The Hoosiers were strongly

attracted to this national expression, especially of Holland, and justly so, for in it was to be found some of the most distinguished work in the whole international.

"It dawned upon them that if this kind of work could be developed in Holland and Norway, then why not in America; and granted that it could be done in America, then why not in Indiana . . . ?"[16]

AND SO WAS born a national dedication, a regional consciousness, pride and ambition, that was reinforced by their Munich teachers. Interestingly, neither Benczur nor Gysis was German. The former was one of the leading Hungarian painters of his time, and Gysis was the finest Greek artist of the nineteenth century. Like the Indiana men, they too were "strangers in a strange land," and both were bringing national artistic glory upon their homeland, albeit as expatriates. The Hoosier artists had the opportunity to utilize their European training and inspiration and to apply it in a more direct national and regional celebration.

In Munich, these artists painted traditional subject matter and their work was well received. Steele's celebrated figure piece, *The Boatman*, won a silver medal in the summer of 1884 in the exhibition of students' work at the Royal Academy. Figure drawing and painting was taught in the academies in Munich, Paris and elsewhere, and portraits and figure pieces were painted by the Hoosier men in Munich. Gradually they moved toward town scenes and

landscapes, often with figures, 'staffage' of peasants and farm animals which became increasingly incidental. Duveneck and Chase were no longer in Munich: the former went to Italy and the latter back to New York. However, J. Frank Currier, one of the leading Americans still residing in Germany, was an important figure of the generation of the '70s. Currier was as much a painter of landscapes as of figures and during his first summer in Germany, in 1881, Steele joined Currier's school[17] in landscape in the little village of Schleissheim only a few miles outside of Munich.

This was perhaps not such a radical departure for Steele, for even as early as 1877, he had exhibited landscapes with the Indianapolis Art Association, and had sketched out-of-doors with John Love. But Schleissheim and Currier proved inspirational. Mary Steele wrote about the beauty of the area and its paintableness in all seasons of the year.

"Its nearness to Munich—six English miles—made Schleissheim a desirable suburban residence, and many artists spent their summers there, while a few lived there the year round. Mr. Currier had his school of landscape at Schleissheim—that is, Mr. Currier worked out there with some fifteen or twenty other Americans, he being the leading spirit . . . There seemed to be no phase of Nature Mr. Currier did not love and study, from the splendid glories of sunset skies, to the tenderest of grey days, soft mists and wind-swept trees. In all his work there was energy and directness of expression, as well as poetic interpretation."[18]

Such a description suggests the strong debt that the mature work of Steele, and his Hoosier companions, were to owe to Currier. It also suggests that the development of outdoor painting, and even the proliferation of schools of outdoor painting throughout America in the 1880s and '90s, may be far more indebted to Munich training than has heretofore been acknowledged, for a great many of the teachers of such classes were Munich men, some fellow-students with Currier, and some students of his. Forsyth also completed his studies at Munich's Royal Academy in 1887 and then pursued his art independently in the countryside.

While these men were developing their painting abroad, the art movement was gathering momentum back in Indianapolis. Although the Indiana Art Association and the Indiana School of Art were short-lived they were not forgotten. The cultural lacuna was at least partially filled in 1881 and again in 1882-83 with lectures on art by Nancy Adsit of Milwaukee, at the home of May Wright Sewall. In 1883 Mrs. Sewall sponsored the Art Association of Indianapolis which held its first exhibition in November with a spectacular display of 453 works at English's Hotel Block. The following January an art school was opened with instruction by Charles MacDonald of Chicago and Susan Ketcham from Indianapolis. It lasted for two years.[19] The first art club in

Indianapolis was the Bohe (for Bohemian) Club, whose leading spirit had been Forsyth until his departure for Munich, and was made up of students and followers of John Love who perpetuated his methods. The Indiana Art Association and the Bohe Club worked together in 1885 on a second exhibition, "Ye Hoosier Colony in Munchen," which was held in the Old Plymouth Church and displayed the work of Steele and Forsyth that had been sent back to Indianapolis. The catalog published for the exhibition is a work of art in itself and one of the most fascinating art publications to emerge from nineteenth century Indianapolis. The pictures and studies of Steele and Forsyth were engraved for reproduction by the members of the Bohe Club and showed the wealth of landscapes painted by the two Munich men. Another link between these early developments and the later growth of the art of Indiana landscape is the activity of Fred Hetherington and Charles Nimli, two of the Bohe Club members who pioneered the exploration of Brown County.

After their training in Munich and their mastery of landscape

21

painting as well as the figure, the Indiana men began to return home to Indiana. Steele returned first, in 1885, settling again in Indianapolis while beginning to gain national recognition by exhibiting in New York City with the Society of American Artists in 1886 and with the Boston Art Club in 1887. John Ottis Adams returned to Muncie in 1887, where he remained for eleven years. In 1888, when Forsyth returned from Germany, Adams and Forsyth opened a school in Muncie. In 1889 Adams began to conduct a school in Fort Wayne which Forsyth also joined. In 1890 Forsyth began a 27-year career of teaching art when he joined Steele, who had begun teaching at the Indiana School of Art in Indianapolis the previous year.

THE DECADE

from 1885 to 1895 was a crucial one for the development of Indiana painting, especially in the depiction of the landscape of the State. This nucleus of Munich-trained men returned to Indiana with a heightened sense of their cosmopolitan professionalism which they were determined to apply to their achievements at home. One way to do this was through their teaching, where their ideals as well as their technical methodology, could proliferate. Another way was to explore more thoroughly their native state. Other than the summer of 1887 which Steele spent in Vermont, the travels of these men brought them to a number of the major urban centers in Indiana. At the same time, they began to fulfill their dedication to the celebration of Indiana by exploring the countryside and by painting what they saw. In September 1886, Steele went for the first time to Vernon (fig. 3) and the Muscatatuck Valley which

22

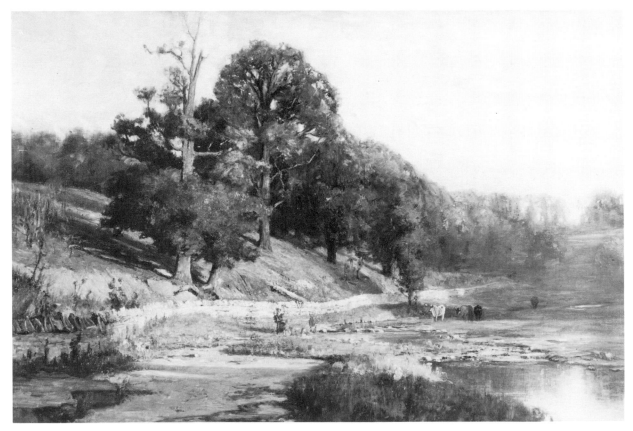

3 Theodore C. Steele
OAKS OF VERNON, 1887
Oil on canvas, 30 x 45 in.
Indianapolis Museum of Art

he began to paint with an assurance and a poetry never before seen in Indiana. In 1892 he was in Hanover on the Ohio River. Forsyth too began to paint along the Muscatatuck and in the Whitewater Valley (fig. 4) and in the neighborhood of Vernon and of Corydon (fig. 5) the old capitol of Indiana. In the summer of 1894 Adams painted at Prairie Dell Farm near Muncie and subsequently held an exhibition of his work done there. The following summer Adams and Steele painted together along the Mississinewa River, north of Muncie.

By then a fourth member of the foreign-trained Hoosier contingent had joined the group. Otto Stark's background and training was somewhat different from those of the others in the group. He was born in Indianapolis but began to study lithography in Cincinnati in 1875. After attending the Cincinnati Art Institute he went to New York City in 1879 to study at the newly formed Art Students' League under Chase and Thomas Dewing. Then in 1884 Stark went to Paris, to the Academie Julian, where he mastered the painting of the figure. Stark returned to this country in 1887 to work in commercial art and settled in Philadelphia. On the tragic death of his wife he returned to Indianapolis in 1892 where, a decade later, he became associated with the John Herron Art Institute. Of more significance was his appointment in 1898 as supervisor of art at the Emmerich Manuel Training High School.[20] The important magazine, *Art Education* recognized "how very fortunate are the pupils of the Indianapolis Industrial High School who now have Mr. Stark for their teacher of drawing and painting," and proposed that "the same arrangement . . . be made in public school art work as in the art of technical schools . . . What a step such a course would be for art appreciation in our high schools! And our high schools need just such a step."[21] More a figure and genre painter than Steele, Adams and Forsyth, Stark painted many of his major works in and around Indianapolis.

W HEN THE Indianapolis painters first returned from Europe they continued the aesthetic manner learned and

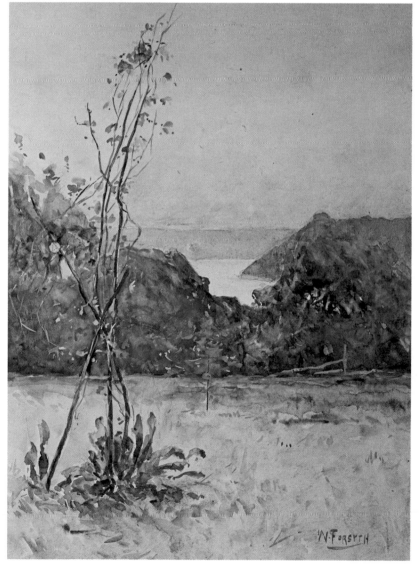

4 William Forsyth
WHITE RIVER VALLEY, ca. 1934
Watercolor on paper, 22¼ × 15⅝ in.
Fort Wayne Museum of Art

23

practiced in Germany. Thus Steele's magnificent *Pleasant Run* (fig. 6) of 1885, painted in that part of Indianapolis which also attracted Stark and other Hoosier artists, is a dark and dramatic landscape backlit with a gray or silvery atmosphere. It is a continuation of the manner he had learned from J. Frank Currier and developed while in Schleissheim. Likewise, even as late as 1894, Adams' Prairie Dell paintings are rural farm pictures, with significant emphasis upon strongly rendered farm figures, which was the American equivalent of the outdoor peasant genre so popular in Europe in the late nineteenth century.

Shortly after he returned to Indiana, Steele began to find more color and contrast in America than in Germany and gradually abandoned the use of the palette knife, the dark underpainting and the thin atmospheric whiteness that he applied to his German work. At the same time that he was beginning to explore the rural beauties of his native state he became convinced that landscape was the preferred form of modern art—especially landscape of a particular place. What is significant here is that Steele, who was the first of the group to return undoubtedly influenced his fellow Hoosiers as they reappeared in Indiana when he turned to the portrayal of specifics of the Indiana scene while simultaneously adopting a more colorful, light-filled and sparkling manner. This style may rightly be defined as a modified version of the then avant-garde current of Impressionism. Hoosier Impressionism was the earliest of regional involvements with this style which had just begun to find American advocates even in New York, Boston and in France about 1887.[22] It remained the favored overall stylistic approach to the interpretation of the Indiana landscape for two or three generations because of its suitability to the subject, its flexibility, and partly too because of its historic association with the increasing acceptance of regional art.

I T WAS AT ART exhibitions in Chicago that modern painting, including impressionist work, and the achievements of painters from America, France and other nations was seen in abundance. The Hoosiers were present and recognized; both Steele and Forsyth were among the exhibitors, and their work was

24

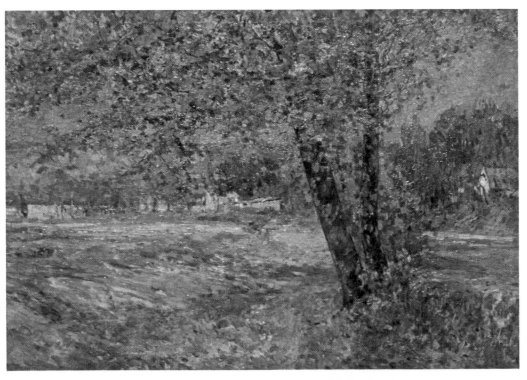

5 William Forsyth
RURAL VILLAGE, CORYDON INDIANA, n.d.
Oil on canvas, 30 × 42 in.
Mr. and Mrs. Richard E. Wise

noted by Hamlin Garland, the most important writer to comment on the show and the champion of midwestern culture.

Garland had been caught up in the earliest excitement over the adoption of Impressionism among the American artists working in Giverny, France. While he was still resident in Boston he saw some pictures sent back from France when they were shown in Lilla Perry's studio.[27] This may have been as early as 1887 when a critic for *The Art Amateur*, writing from Boston, noted that "A few pictures just received from these men show that they have got the blue-green color of Monet's Impressionism and 'got it bad'."[28] Garland then began to champion Impressionism, but his preference was basically with a more tempered and consciously native adaptation of the aesthetic which he admired in the work of John Enneking in Boston. Garland brought his enthusiasms and considerations with him to Chicago. In his seminal essay on "Impressionism," originally delivered in Chicago as a lecture but published in *Crumbling Idols* in 1894, he voiced his appreciation for the new art form, but also noted that "the work of a man like Enneking or Steele or Remington, striving to paint native scenes, and succeeding, is of more interest to me than Diaz."[29]

This may have been Garland's introduction to the Indiana painters in general, and to Steele's work in particular but he was soon to become more familiar with them. In March 1894 Garland was one of the founders and, for a short time, the president of the Central Art Association in Chicago. The purpose of the Association was to promote the arts throughout the Midwest through the sponsorship of exhibitions, lectures and the publication of a monthly journal, *Arts for America*.[30] One of the most interesting of its publications appeared in the autumn of 1894, entitled *Impressions on Impressionism*, which recorded a discussion of the "Seventh Annual Exhibition of American Paintings" at the Art Institute of Chicago by three thinly disguised figures of the Chicago art world—Garland, the sculptor Lorado Taft, and the conservative landscape painter, Charles Francis Browne. Browne, the painter, still championed

25

6 Theodore C. Steele
PLEASANT RUN, 1885
Oil on canvas, 19¼ × 32½ in.
Indianapolis Museum of Art

more conservative tonal, Barbizon works; but Garland and Taft were more receptive to Impressionist pictures and especially the Indianapolis ones. Garland remarked, "That canal of Steele's up there, seems to me to be a most admirable example of good clear painting. Steele is a western man who has won the respect of his eastern brethren." But he also noted that, "What I miss in the whole Exhibition I miss in American art— and that is the drama of American life."

The subscription to Impressionism was gradual. It almost surely evolved naturally rather than as deliberate choice, but it was not unconscious. As Forsyth wrote about their experiences, "the influence, first of the plein airists, as out door painters were called, and afterwards that of the impressionists prevailed, and the pure colors and light in all its phases are the dominant traits in all these Hoosier artists' works. Impressionism has influenced all of them to a greater or less extent and has taught them more than any other single factor. Each took from it what best suited him and each has made it part of himself; and if they are often called impressionists it is not without truth."[23] The Hoosier painters understood Impressionism well; they were able to write intelligently about it and to practice it. Steele wrote an article on "Impressionalism," for the first issue of the magazine *Modern Art* in 1893; that same year Forsyth wrote about Impressionism at the Columbian Exposition; and two years later Otto Stark wrote one of the most fascinating contemporary histories of the

development of that aesthetic in "The Evolution of Impressionism."[24]

Modern Art was unquestionably the finest art magazine to appear in this country in the last decade of the century.[25] It was the first published in Indianapolis in 1893 and reflected both the sophisticated state of the arts that had developed in Indianapolis in so short a time and the modernity of art expression that was recognized nationally. *The Art Amateur*, in March noted that, "Among the Indianapolis painters whose work is making some stir in the West, T. C. Steele is pre-eminent for broad handling, poetic spirit and agreeable color. He is of the Impressionist school, and deals in the glorification of the commonplace Indiana landscape."[26] By that year, Adams too had turned to Impressionism, while Stark in his 1895 essay predicted that modernity, in the aftermath of the new aesthetic, would consist of its Americanization.

Modern Art reflected more than the cultural awakening of Indianapolis; it signified the emergence of the Midwest as a serious, sophisticated entity in the artistic life of the country. Although *Modern Art* itself may have appeared in Indianapolis somewhat prematurely, and stayed for only two years before it was moved to Boston for the

remainder of its four-year run, it was followed by such long-lasting art periodicals as *Brush and Pencil* and the *Fine Arts Journal*. These were Midwestern journals of vital significance to the cultural life of the nation. They were published in Chicago where, in 1893, the Columbian Exposition proved the vitality of the Midwest. When Browne echoed these sentiments by stating that "American art must be developed by the artists in happy sympathy with American surroundings," Garland replied "What pleases me about the Exposition is that while the principle of impressionism is almost everywhere it is finding individual expression. Henri and Herter, and Steele, and Tarbell, and Vonnoh, and Robinson all have a different touch—they are gaining mastery of an individual technique."[31]

Garland and his colleagues were searching for an Americanization of the new aesthetic. One was developing at this time in Indianapolis. It had its most historic showing in November 1894 at the Denison Hotel, where other exhibitions sponsored by the Art Association of Indianapolis had also been held. This show consisted of summer work painted in Vernon (fig. 7) and the Muscatatuck Valley by Steele, of figure and landscape paintings by Stark and Forsyth, and of a group of landscapes in oil and in watercolor by Richard Gruelle (figs. 8 & 9) a Kentucky-born painter who was self-taught and had been resident in Indianapolis

since 1882. Gruelle was a more conservative painter, most admired today for his sensitive, tonal scenes along the waterways in Indianapolis. He is also known for his authorship of the 1895 catalog of the great art holdings of the Baltimore collector, William T. Walters. There seems some dispute as to whether Garland visited this show in person or not, but it is known that he invited the exhibition to be repeated in Chicago in Lorado Taft's studio in the Chicago Athenaeum Building under the sponsorship of The Central Art Association.

This exhibition, in turn, led to a second publication of the discussion among Garland, Taft and Browne, who collectively identified themselves as The Critical Triumvirate. It was this publication, entitled "Five Hoosier Painters," that inaugurated the term that refers to the core group of Indianapolis painters: Steele, Forsyth, Stark, Gruelle, and John Ottis Adams, two of whose works were added for the Chicago exhibition.

IF THE CRITICAL

Triumvirate were searching for a truly Americanized modern art in Chicago in the fall of 1894, they found it that winter. This was all the more astonishing because, as they collectively wrote: "These men were isolated from their fellow-artists, they were surrounded by apparently the most unpromising material, yet they set themselves to their thankless task right manfully—and this exhibition demonstrates the power of the artist's eye to find floods of color, graceful forms and interesting compositions everywhere."[32] For Taft, the special achievement of the Hoosiers was their individuality: "I have failed to find a single picture here which looks as if it had been founded on another man's work." He did acknowledge, though, that "Steele seems the biggest man of the lot," and later noted that "I remember that the World's Fair jury of admission were enthusiastic over Steele's work, saying that they had discovered a 'strong' man in Indianapolis. His pictures there were the first I had seen of his work . . ." Garland noted that he had met Steele and, indeed, Steele's works were discussed at greatest length, including his *The Bloom of the Grape* (fig. 10) a Muscatatuck Valley picture painted in 1893 which is perhaps the best-known of all Hoosier landscapes. Even the conservative Browne found it "fresh in color and free in handling," and Garland stated that "Steele leads I guess, considered as final achievement, but Stark shows great facility and reserve force."

27

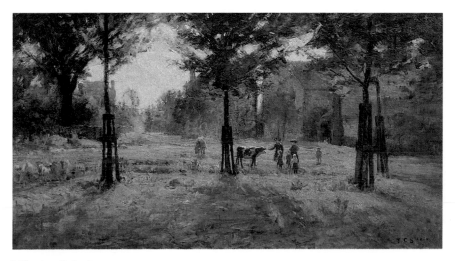

7 Theodore C. Steele
SUMMER DAYS IN VERNON, 1892
Oil on canvas, 22¼ × 40 in.
Private collection

The Chicago critics were also concerned and delighted with the regional and national achievements of the Hoosier painters. As Browne said: "They prove the West is not prosy and unpicturesque. It only needs the eye to see it. Sunlight is sunlight the world over and it beautified Indiana as well as France." Garland added that: "A group of men like these can transform the color sense of the whole west—or more truly awaken the unconscious color sense. This exhibition can hardly be over-estimated in its effect on our western painters."

What all three critics admired was the manner in which that awakening was taking place; although it was a modern it was not a radical aesthetic. Browne decided that "These men are conservatively impressionistic,

they are not 'wild,' . . ." and Taft noted that the artists "had selected the better part of impressionism . . . that one of the great lessons of impressionism has been to teach our painters how to focus the attention upon some important feature in a canvas and how to slur and subordinate non-essentials. The extreme impressionist slurs everything."[33]

Hamlin Garland's vision was not lost on Chicago, judging by the reaction of Harriet Monroe in *The Critic*. Her review is worth quoting extensively:

"I wondered what Hoosier art would prove to be, as I obeyed the call of these five unknown men, for, though one or two had shown pictures at the Fair, I must acknowledge having passed them by. But, as I entered the studio, I was impressed by the sense of something new and fine like the emotion which assailed me at the first view of the Swedish

exhibit at the Columbian Exposition. Here is an indigenous art—a group of sincere men modestly and eagerly giving us their own. The effect here as there is strengthened by the harmony of the exhibit: men working in the same mood over the same beloved fields and rivers, and showing their work together. Yet there is no monotony—these painters differ widely in temperament and method. Mr. T. C. Steele, who, perhaps, leads the group, is a dreamer in landscape, a poet who loves autumnal glories and the blue mists that rise from winding rivers, and who gives us the very quiver of an August haze. There is distance in his pictures, and shining air and stillness and color, and above all, love—that love of all the phases of familiar nature which must have begun when he was born, and is still

28

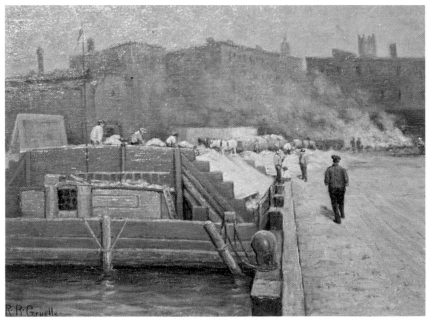

8 Richard B. Gruelle
ON THE CANAL, n.d.
Oil on canvas, 17½ × 32½ in.
Mr. and Mrs. Richard E. Wise

strengthening. Mr. Otto Stark is younger and less complete in his development, but probably quite as interesting. His children are delightfully child-like and American, and from him one learns the spaciousness of the prairies. One prairie sunset by him—a landscape which is all sky, gorgeous scarlet and green and purple sky—is a pure song. The other men, Mr. P. O. Adams (sic), Mr. William Forsyth and Mr. R. B. Gruelle, are none of them commonplace, each having his points of strength and charm. Altogether the work of this Indianapolis group is sincere, imaginative and significant."[34]

FROM THEN ON,

the work of the Hoosier painters was an integral part of not only the local, but also the regional and sometimes the national scene. Hoosier art appeared often in Chicago, where it was often deemed the strongest showing of any of the contributions from the large urban centers of the Midwest. In the combined exhibition of the Palette Club—an association of women artists—and the Cosmopolitan Art Club—comprised only of men—which took place at the Art Institute of Chicago in January 1895, Adams showed two works, Stark three, Forsyth two and Steele four. Forsyth and Steele were members of the Club. Among Steele's pictures were *On the Muscatatuck* and *Afternoon on the Muscatatuck*, which should be taken into account when

29

9 Richard B. Gruelle
THE CANAL, MORNING, 1894
Oil on canvas, 32 × 38 in.
Indianapolis Museum of Art

considering Hamlin Garland's introduction in the exhibition catalog:

"Monet makes Giverny. Giverny does not make Monet. The light floods the Kankakee marshes as well as the meadows and willows of Giverny. The Muscatatuck has its subtleties of color as well as L'orse, and a little young haymaker on the banks of the Fox River is certainly as admirable for art treatment, in paint or clay, as a clumsy Brittany peasant in wooden shoes . . . there are indications that the artists of the west are coming to this stage of spontaneous original effort. Already studies of Chicago streets, of Indiana meadows and streams, of Utah harvest fields, of the Indians of the prairies, of Lake Michigan villages, and of farm and city life are being made in clay and bronze, in paint and pastel. Everywhere the breath of creative impulse is beginning to be felt."[35]

The position and importance of The Hoosier Group was officially recognized and consolidated the following year, 1896, with the establishment of The Society of Western Artists, a self-constituted body of Midwestern painters who organized yearly itinerant exhibitions of contemporary art from the region. Artists from Chicago, Cincinnati, Indianapolis and St. Louis, with a smaller contingent from Detroit and Cleveland formed exhibitions that travelled to the six Midwestern centers. Steele, Adams and Forsyth were on the board of the Society representing Indianapolis, and Stark was added by 1897. Forsyth was elected vice-president, with Frank Duveneck from Cincinnati as president. In later years, John Elwood Bundy of Richmond, Indiana was also a member. Numerous other Indiana artists such as Richard Gruelle and later, painters such as Carl Graf, also showed with the Society. Critics constantly noted the strength of the Indiana contingent.

OUTSIDE OF Indiana itself, St. Louis remained even more receptive to contemporary

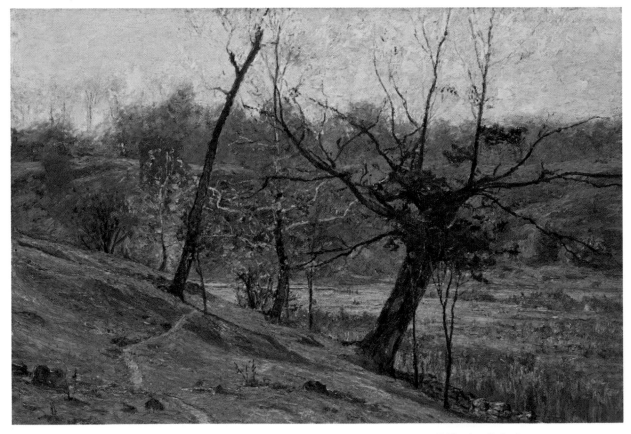

10 Theodore C. Steele
THE BLOOM OF THE GRAPE, n.d.
Oil on canvas, 30⅛ × 40⅛ in.
Indianapolis Museum of Art

30

midwestern painting and particularly the art of the Hoosiers than Chicago. This was due in large part to the advanced and liberal thinking of Halsey Ives of the St. Louis Art Museum. In 1896 the Museum held a two-man show of the work of Steele and Adams, in which many of the paintings that the two had done along the Mississinewa were shown. Ten years later, the Museum mounted the First Annual Exhibition of Selected Paintings by Western Artists, meant to be compared to the annual shows of the Society of Western Artists which were traditional by then. By choice it was a smaller exhibition with fewer but stronger artists; four each from Chicago, Cincinnati and St. Louis; and Forsyth, Stark and Steele from Indianapolis. Interestingly, one of the Chicago artists, Alexis Fournier, would later be associated with Indiana landscape painting, both in South Bend and in Brown County.[36]

In 1898, the same year in which Steele succeeded Duveneck as the president of the Society of Western Artists, Steele and Adams jointly acquired a house in Brookville that they named The Hermitage. Adams lived there throughout the year and Steele spent several summers there. Also in 1898, Adams married his pupil, Winifred Brady, destined to become one of the finest still-life specialists in the state. During the next decade many of the finest paintings of Adams and Steele were the landscapes painted at The Hermitage. The valley of the Whitewater (fig. 11) attracted the Munich-trained painters on their

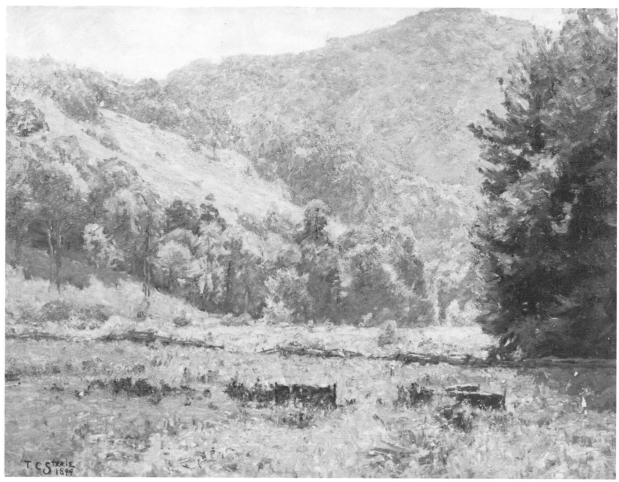

11 Theodore C. Steele
WHITEWATER VALLEY, 1889
Oil on canvas, 22 × 29 in.
Ball State University Art Gallery

31

return from abroad, in part because it reminded them of the foothills of the Alps where they had painted a decade earlier. By the end of the century, much of the creative spirit in Indiana landscape painting was concentrated in the east-central section of the state. Steele and Adams were working in Brookville and others such as Forsyth visited them at The Hermitage.

It was during the Brookville years that Steele's commitment to Impressionism in his landscape work increased. *The Old Mills* of 1903 depicting the old paper mill in Brookville, was one of the paintings that he exhibited at the Louisiana Purchase Exposition in St. Louis in 1904. It reveals a varied chromaticism beyond the "conservative Impressionism" that had been admired in Chicago a decade earlier.

Another important group of painters were working in Richmond, about thirty miles from Brookville, also on the Whitewater River.[37] The artists of the Richmond Group, led by Charles Conner, Frank Girardin and John Elwood Bundy, were somewhat more conservative than the Indianapolis artists. They kept more to Barbizon-inspired tradition of tonal painting which was the dominant landscape style in most of America in the 1880s when these men gained importance. Most of the Richmond artists had not been exposed to foreign training or to foreign aesthetic developments as had their Indianapolis counterparts. It is therefore understandable that, compared with the Hoosier Impressionists they did not readily investigate wide color ranges, nor did they forsake dark shadows and neutral tones. Girardin's painting is somewhat more prismatic and slightly tinged with sunlight which was a concern of his Indianapolis contemporaries (fig. 12); but Conner, who was Richmond-born and self-taught, painted completely in a dark and poetic Barbizon mode (fig. 13). Conner was recognized as the dean of Richmond landscape

32

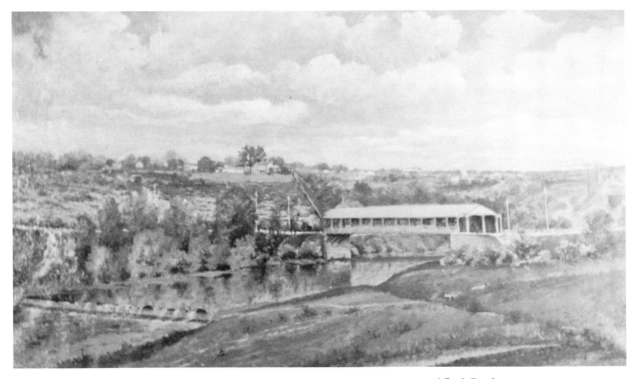

12 Frank Girardin
COVERED BRIDGE, n.d.
Oil on canvas, 23½ × 41½ in.
Art Association of Richmond

painters, although he was only 48 years old when he died. Subsequently, the best-known painter in the Richmond Group, and the most influential among them, was John Bundy. Bundy had studied in Indianapolis for a short time with Barton Hays before seeking further training in New York City. Bundy was significant not only as an artist but also as a teacher. He had a small class in Martinsville, Indiana in 1886-87 before accepting a teaching position at Earlham College in Richmond in 1888. Bundy was particularly noted for his fascination with the forests of beechwood trees in autumn (fig. 14) stressing the subtle tonal variations of brown and rust in the fall foliage and the tree bark. Repetitious though such works may seem, at their best Bundy's woodland scenes achieved a poetic beauty that was recognized by Chicago galleries and that carried his fame beyond Indiana. Bundy's work, in fact, offers greater variety than is usually acknowledged. Some of

33

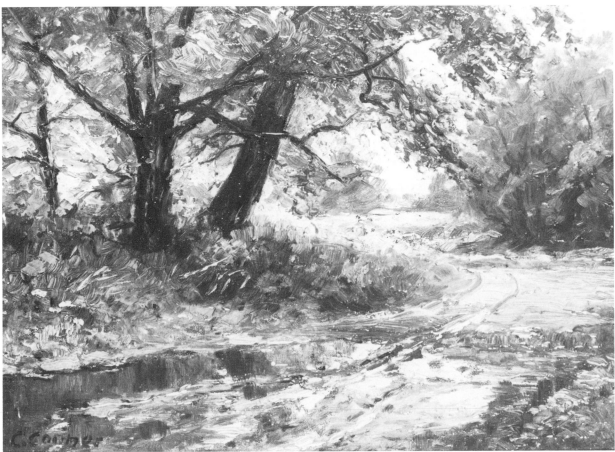

13 Charles Conner
THE RIVER ROAD, n.d.
Oil on board, 8¾ x 12 in.
Mr. and Mrs. Gordon Gates

his finest paintings are sparkling, pristine winter scenes (fig. 15), which project a greater clarity than his autumnal beechwood pictures. He, along with Frank Dudley, was one of the interpreters of the Indiana dune country (fig. 16).

The work of these and many other local artists active in Richmond in the 1880s and '90s led to the organization of the Art Association of Richmond in 1898. The Association provided official support for these artists, most of whom devoted their talents to recording the beauty of the surrounding countryside.

This grass-roots art development for the Richmond painters did not escape national notice although recognition came later than that for The Hoosier Group in Indianapolis. A writer on " 'The Richmond Group' of Painters," in *The Art Interchange* in 1903 remarked, "In the Middle West painters are producing work more distinctively American, perhaps, than in any other section of the country."[38]

INDIANAPOLIS

remained the official base for the original Hoosier Group, even though the valley of the Whitewater and other rural areas were sources of inspiration. Stark

was teaching there at the Technical High School and Adams, though resident at The Hermitage, started teaching in 1902 at the Herron Art School, where Forsyth was already an instructor. Among the students were a number who would later be involved with the Brown County School: Marie Goth, Carl Graf and Clifton Wheeler. Wayman Adams of Muncie—no relation to John Ottis Adams—was also a student at The Herron, before going on New York to study with Chase and Robert Henri.[39] Although Wayman Adams became known in his maturity almost exclusively as one of the finest portrait painters of his time, he did paint some rural

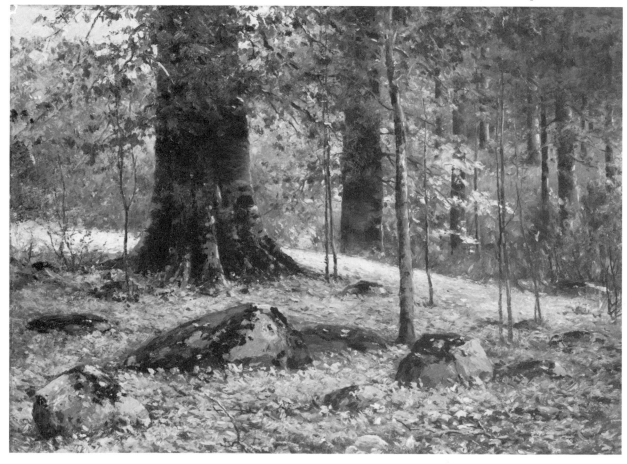

14 John Elwood Bundy
THE MONARCH BEECH, n.d.
Oil on canvas, 28 × 35 in.
Indianapolis Museum of Art

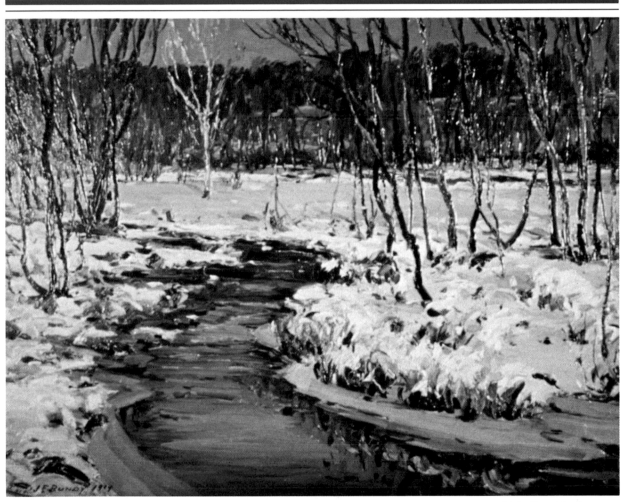

15 John Elwood Bundy
WINTER SCENE, 1914
Oil on canvas, 15⅞ × 20⅜ in.
Mutual Hospital Insurance, Inc.

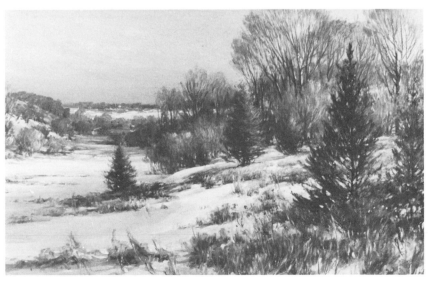

16 John Elwood Bundy
INDIANA DUNES, 1924
Oil on canvas, 28 × 28 in.
The Snite Museum of Art

landscapes at the beginning of his career. *Haying in Indiana* (fig. 17) was very much in a Barbizon tradition and was perhaps influenced by the work of Conner and others in Richmond, not far from his native Muncie. Adams continued to send his work for exhibition in Indiana long after he had left the state. His painting, *The Art Jury*, of 1921, which has often been judged his masterpiece of portraiture is a unique testament to The Hoosier School, depicting the elderly Steele, Stark, Adams and Forsyth as they served in official capacity.

Indianapolis also provided the Hoosier painters with subject matter. Stark particularly, more city-bound and more closely associated with figure painting, frequently painted there. In his 1917 oil painting, *Wet October* (fig. 18) or the 1911 gouache of *Sunflowers* (fig. 19), he effectively contrasts the close-up view of a patch of gloriously colored nature with a hazy, distant sketch of buildings. In the latter work, the State Capitol is indicated in the far background. Occasionally throughout his career Steele also painted urban views in downtown Indianapolis. These are particularly effective when the long streets and tall buildings are set within the dark of evening or a blanket of snow, as in Stark's city pictures. As juxtapositions of man's urban environment with the effects of nature such midwestern scenes are related to the eastern scenes of Henri, John Sloan and others of The Ashcan School.

F OR THE Hoosier painters the most memorable project in Indianapolis was the decoration of the children's wards in the Burdsall units of the City Hospital. The Guild of St. Margaret, of St. Paul's Episcopal Church, provided a fund for a mural project which was led by Forsyth. The decorations were begun in 1914 and completed by the end of the following year. Thirteen noted Indiana artists were involved, painting both figure and landscape pictures on a monumental scale. Clifton Wheeler and Carl Graf received the initial commissions and worked with Steele, Stark, Forsyth, John Ottis Adams and Wayman Adams among others. Stark had previously completed his first pair of murals, *Springtime* and *Autumn*, for the auditorium of Public School 60 in Indianapolis in 1913, and in 1917 he was involved in painting the gigantic Liberty Bond mural for Monument Circle in downtown Indianapolis with which Forsyth, Graf and Wheeler were also involved (photo p.9).

In the early years of the twentieth century, many of the Hoosier painters were beginning to venture farther afield, both for painting and recreation. In 1905 Adams began to summer in Leland, Michigan where Stark joined him, setting up a tent a quarter of a mile away. In 1915 Stark and Adams started going to Florida, first to St. Petersburg, where Stark was recuperating from

illness and then, in 1919, to New Smyrna. Both artists painted rather haunting lakeside views in Michigan and more exotic scenes in Florida. Steele visited his family in Oregon and in southern California in the summer and autumn of 1902, and again the following year, producing many beautiful canvases of the wild Oregon coast and colorful panoramas of California. Steele was apologetic concerning this temporary defection from the glorification of his native state.

That devotion to Indiana led Steele to take a new turn later in the decade. Restless after the death of his first wife in 1899, and with his children grown up and married Steele searched for a new painting ground. In the fall of 1906 he explored what was then a primitive Brown County. Attracted by its

woodland and undulating terrain he purchased land, built a studio-home in April of 1907, and brought his new bride, the former Selma Neubacher, to it in August. The home, The House of the Singing Winds, remained Steele's painting base for the rest of his career. It was from there, and the several studios he built upon his increasing land holdings, that he painted the finest of his later works including pictures of the house itself.[40]

Exhibitions and numerous honors came to Steele during his final two decades. The first of these was a one-man exhibition of *A Special Collection of Paintings by Theodore C. Steele* which opened in

December 1907 at the St. Louis Museum of Fine Arts and showed 33 Brown County landscapes, including one entitled *To the House of the Singing Winds*. The brief biographic note appended to the catalog acknowledged Steele as the dean and leader of the Hoosier

37

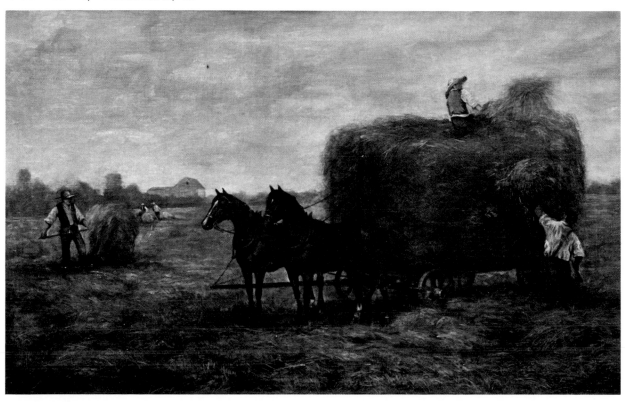

17 Wayman Adams
HAYING IN INDIANA, n.d.
48 × 29¾ in.
Mr. and Mrs. Richard Wise

painters, the one who had advanced the appreciation of the arts not only through his brush but through many activities associated with art. He was cited for not being "an extremist in style or color."

In 1910, the John Herron Art Institute in Indianapolis held a major retrospective of Steele's work, containing 73 pictures dating from 1873. Ten years later the Institute held another exhibition of 44 works, concentrating on the Brown County years, showing many landscapes, some still lifes, and one earlier, Brookville painting. In 1926, the Art Association of Indianapolis mounted a memorial exhibition of almost 200 of Steele's paintings at the John Herron.[41]

Other honors came to Steele. In 1913 he was made an Associate Academician of the National Academy of Design in New York—a truly national recognition for a Hoosier painter. In 1916 he received an honorary doctorate from the University of Indiana which mounted an exhibition of his work that year.[42] From that exhibition came the first acquisition of what would become a sizable holding of Steele's landscapes, and in 1922 he was made an honorary professor of art at the University. The literature on Steele and his art began to appear in national art periodicals in the 'teens. Steele continued to advance the arts by lecturing which he had begun as early as 1890. Steele had lectured extensively in Indiana, Chicago and elsewhere promoting Indiana art and modern art, and defending Impressionism in the early days of the movement. Steele's final

lecture, given the year before he died, was entitled "The Art of Seeing Beautifully," and was presented before the Fort Wayne Art School and Museum on December 4, 1925, on the occasion of an exhibition of work by the artists of Brown County.[43]

Steele was a formative influence in the development of Brown County as a major art colony, and as the center for the continuation of a tradition of landscape painting in Indiana which has continued to

the present. Artists had been drawn to the area much earlier, as has been mentioned, but Steele's presence underscored its importance. Despite the fact that it was only about 60 miles from

18 Otto Stark
WET OCTOBER, 1917
Oil on canvas, 20¼ × 15¾ in.
Mr. and Mrs. Gordon Gates

38

Indianapolis the growth of the Brown County art colony was limited to those artists who were not discouraged by the primitive nature of the facilities and the difficulties of transportation. An additional concern among the artists was to be able to make their art accessible to patrons in their studios and at exhibitions. These difficulties were somewhat eased when, in the summer of 1905, the Illinois Central Railroad began making stops in Helmsburg in the County, but even then it was a difficult journey to the county center in Nashville, the future home of the Brown County Art Association.

IT WAS THE

expansion of the dairy industry in Wisconsin that changed the landscape and spoiled it for the artists. Cows were being put to pasture in the previously empty fields and along the streams.

Vanderpoel concurred with Shulz that a new site for art activity might be more desirable. In August 1900 Shulz read an article in a Chicago newspaper describing the untouched beauty of Brown County. He set off to investigate, taking the train to Indianapolis and then travelling by horse and buggy to Brown County. On his return he wrote:

"Never before have I been so thrilled by a region: it seemed like a fairyland with its narrow winding roads leading the traveller down into creek beds, through water pools and up over the hills. Picturesque cabins seem to belong to the landscape as did the people who lived in them. I was impressed by the beautiful and dignified growth of timber. All this country is enveloped in a soft, opalescent haze. A sense of peace and loveliness never before experienced came over me and I felt that at last I had found the ideal sketching ground."[48]

In March 1907 the plans to colonize Brown County matured when, at a meeting in Chicago's Palette and Chisel Club, Shulz persuaded a group of his colleagues to explore Brown County.[49] After the trip all agreed on the beauty of the area and decided to return as soon as possible. Shulz returned that summer, and after a fateful meeting with Steele, who was building The House of the Singing Winds he selected nearby Nashville as his base. The following year Shulz began to lure about 25 Chicago area artists to Brown County, some for occasional or frequent visits,

19 Otto Stark
SUNFLOWERS, 1911
Gouache on paper board, 22½ × 15¾ in.
Mr. and Mrs. Gordon Gates

39

some to stay. Adolph and Ada Shulz began in 1908 to spend summers in Nashville and in 1917 they closed their Delavan home in order to live in Nashville, Indiana, all year.[50]

Shulz appears to have continued to work in a late Barbizon poetic manner through the early years of the twentieth century. His more broadly painted and more colorful canvases are those associated with Brown County. It may be that his stylistic transition coincided with his move to Indiana and may even have been influenced by Steele's art (fig. 20).

Ada Shulz was a figure painter, a specialist in paintings of mothers with children. Some of the most attractive of these are outdoor paintings, in which the idyllic beauty of the Brown County landscape reinforces the joy and tranquillity of the maternal relationship. Others of her home scenes emphasize children, sometimes with their pets, sometimes performing simple tasks in the house, or playing in flower-filled fields.

AN EVEN

more significant factor than the availability of the railroad to the Brown County art colony was the development of the dairy industry in southeastern Wisconsin and its proximity to Chicago. Chicago was the largest metropolis in the Midwest and the school of the Art Institute of Chicago was the major art educational facility in the region. The instructors and students at the Art Institute were aware of the major pedagogical development of the late 1880s and early '90s. The Impressionist aesthetic was pursued through formal summer instruction in outdoor painting concentrating on landscape painting, and giving attention to outdoor light and color. It is believed that Charles E. Boutwood was seeking an outdoor painting area in an attractive landscape setting that was

convenient to Chicago when he came upon Delavan, Wisconsin. About 1892 he began to hold summer classes there with his fellow instructor at the Art Institute, John H. Vanderpoel.[44] Vanderpoel was the more influential teacher of the two and was the author of an important treatise on art instruction. Each summer he led a class of students from the Art Institute to Delavan where instruction was similar to that of the famous Shinnecock Art School run by William Merritt Chase on Long Island.

The site of Delavan, together with its surrounding countryside, the beauty of Lake Como with its mill pond and mill race, the hospitable facilities offered at the Hotel Delavan, all made the town a desirable center for such activities. As Vanderpoel himself wrote in 1899 with direct reference to Indiana's James Whitcomb Riley, "The winding stream in the valley made deep by the overhanging trees, running thru reeds and decked with lily path,

with its springs and swimming hole would delight the Hoosier Poet."[45]

The artists in Vanderpoel's classes were both amateurs and future professionals. They came from all over the Midwest, with a preponderance from Chicago. A few were from Delavan, the most notable of whom was Adolph Shulz. Shulz had studied earlier with Vanderpoel, and must have been one of Vanderpoel's first pupils when he began teaching at the Art Institute in 1888.[46] Shulz went on to study with Chase and H. Siddons Mowbray at the Art Students' League in New York before going to Paris to study at the Academie Julian.[47] When he returned to Delavan in the late 1890s Shulz began to paint the Wisconsin landscape. These paintings were scenes cloaked in soft fogs and mist; they were often moonlight scenes in the currently popular tonalist manner. Shulz together with his talented wife, Ada Walter, whom he had met at the Art Institute and married in 1893, aided and encouraged many of the artists who visited Delavan in the summertime. Between Vanderpoel's art classes and Shulz' year-round activities Delavan became known as the "art capitol" of the region.

It was Shulz who was to become the pied piper to lead the artists

41

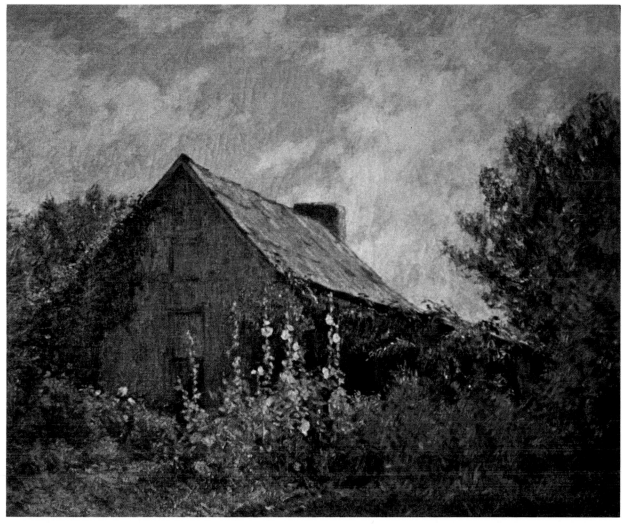

20 Adolph Shulz
HOME SWEET HOME, 1933
Oil on canvas, 30 × 36 in.
Jay and Ellen Carter Art and Antiques

from Chicago and Delavan to Brown County. The cause for the migration was the proliferation of cows, and clearly Delavan's loss was Brown County's gain.

Accompanying Shulz on his trip to Brown County early in 1907 were his fellow Chicago-area painters, Louis Oscar Griffith, Wilson Irvine and Harry L. Engle, each of whom would visit Indiana frequently during the ensuing years. Griffith had been born in Greencastle, Indiana, and had studied with Frank Reaugh, a Texas painter who specialized in pastels used in a delicate, near-Impressionist manner. Griffith painted landscapes in pastels as well as in oils. These paintings celebrate the beauty of Brown County in rich summer sunlight, often including local rustic structures as in his *Owl Creek Valley Farm* (fig. 21). Shulz, Griffith, and many of the other Brown County landscape painters emphasized the role of man and his farming activities in their Brown County scenes. These are rural, domestic landscapes, in which the farm buildings become the focus of the composition.

The relationship between the early artists of Brown County and the local inhabitants was sometimes tenuous. A few of the residents accepted the painters from the first. Bill and Mandy Pittman welcomed the artists to their Nashville hotel—or sanatorium as they called it. But the majority of the permanent residents of the county were

42

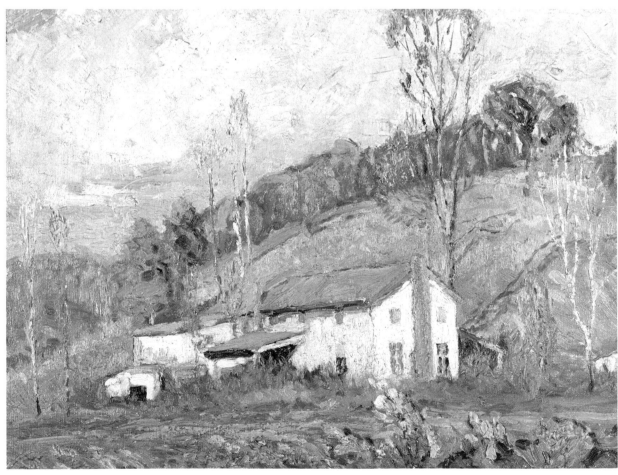

21 Louis O. Griffith
OWL CREEK VALLEY FARM, n.d.
Oil on canvas, 20 × 24 in.
Mr. and Mrs. Frank R. Stewart

suspicious of the city people, especially when the artists showed an inclination to upgrade the living standards, improve the roads and modernize the area. These were the same natives who had successfully stopped the railroad from putting a line through what they called the 'Peaceful Valley,' where it would have stopped at Nashville. Steele and his fellow artists eventually won over the local inhabitants as progress and prosperity came to Brown County, but it was a long struggle.[51]

Will Vawter was another early Brown County artist who arrived in 1908. His fame in Indiana is attributable to his success as an illustrator, especially of the works of James Whitcomb Riley, and also to his landscape paintings of rural scenes which were sometimes similar to those of Shulz, although occasionally they were more dramatic (fig. 22).

Lucie Hartrath was probably the most talented of the women landscape specialists associated with Brown County. She was born in Boston, and studied with Vanderpoel in Chicago in the mid-'90s, before going on for further training in Paris and

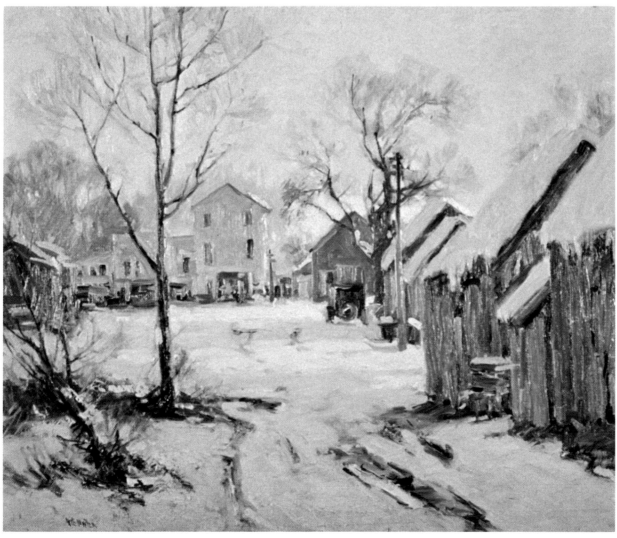

22 Will Vawter
SCENE OF AN ALLEY, A CAR, AND SOME BUILDINGS, n.d.
Oil on canvas, 30½ × 36½ in.
Greater Lafayette Museum of Art

43

Munich. She lived in Chicago from 1906 but spent summers and autumns almost every year in Brown County. It was there that she painted some of the most idyllic Brown County landscapes known (fig. 23).

At one time, a Brown County artist whose national acclaim almost rivaled that of Steele, was Adam Emory Albright.[52] Albright was born in Wisconsin and was not a landscape specialist but Brown County served him and his art well. Albright studied at the Art Institute of Chicago, at The Pennsylvania Academy of the Fine Arts under Thomas Eakins, in Munich with the Wisconsin expatriate, Carl Marr, and in Paris, before returning to Chicago in 1888. Albright's thematic career is an interesting one. He began painting pictures of downtrodden urban youth—newsboys, bootblacks. These midwestern youth were

44

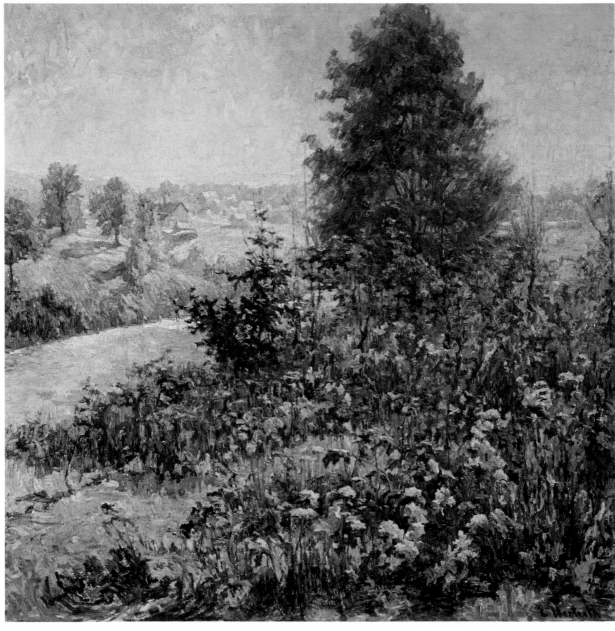

23 Lucie Hartrath
AUTUMN PAGEANT, n.d.
Oil on canvas, 42 × 42 in.
Union League Club of Chicago

supposedly much more earthy and gritty than their eastern counterparts depicted by the popular John George Brown. He then painted some more ambitious pictures; one of an elderly·man lying dead on his hearth; another of a young woman in death, *In the Morgue*. But his audience, and even Albright himself, recoiled from such subject matter, and he returned to the depiction of

youth. The children were no longer urban urchins but were country children shown outdoors. The children sometimes included girls, but were often boys alone (fig. 24). Usually he used his own children as models, first his oldest son and then his twin boys, Ivan and Malvin Albright (fig. 25) who would themselves become notable painters of the following generation.

Adam Albright was one of Chicago's leading artists. He lived and had a studio outside the city, in Edison Park from 1899, then in Holland Woods, and finally in Warrenville. The Art Institute of Chicago gave Albright more one-man exhibitions than any other contemporary Chicago artist. In 1908 he began to visit Brown County where he painted some of his finest studies of country youths: the children are one with gentle, informal nature, and all are bathed in rich, warm, glowing sunshine. Although The Hoosier poet was portrayed often by Theodore Steele, and his writings were illustrated by Will Vawter it was Adam Albright who was called the James Whitcomb Riley of the brush.

An extraordinary number of distinguished artists visited Brown County, and some eventually remained there. Many of them already had, or were soon to gain strong regional reputations, which today are in the process of reexamination and revival. One of the best-loved of the early visitors was John Hafen, perhaps Utah's most distinguished painter. He spent three seasons in Brown County, from 1908 to 1910, until his untimely death. Most of the artists were painters of landscape, but one of the best-known was Gustave Baumann, a German-born specialist in woodblock printing who first arrived in Brown County in 1910 and remained until 1918 when he moved to the artists' colony in Santa Fe. The history of art in Brown County is associated not only with Indiana art, but with

45

24 Adam Albright
LOG IN THE STREAM, n.d.
Oil on canvas, 48 × 35 in.
Union League Club of Chicago

the progress of painting in Chicago, through the great numbers of landscape painters from there who visited and worked in Indiana. In addition to those already mentioned, Carl Krafft and Rudolph Ingerle were distinguished Chicago landscape painters who were early members of the Brown County art colony.

THE BROWN

County experience, in turn, led these artists to explore other little-known midwestern rural areas. The Society of Ozark Painters was founded in the 'teens by a group of Chicago and St. Louis painters who had summer studios in the area of the Gasconade and White Rivers in southwestern Missouri. Krafft was president of this regional group and painted a series of stunning landscapes of the region while, unfortunately, his Brown County work has yet to surface.[53] Ingerle later began to promote the rural beauties of the Smokies for landscape painters, in the area of western North Carolina and eastern Tennessee.[54] Brown County thus became the prototype for art colonies throughout the greater Midwest where painters could explore and exploit the unspoiled beauty of distinctive countryside. Even Grant Wood's Stone City art colony in Iowa, formed in the early 1930s, used Brown County as a prototype.

Brown County continued to attract painters, as it does to this day. Another generation was established in the early 1920s when the artist Alberta Shulz, the second wife of Adolph Shulz, invited Marie Goth to Brown County. Goth had studied in Indianapolis with Otto Stark at the Emmerich Manuel Training High School, and subsequently in New York at the Art Students' League under Chase, Frank DuMond and F. Luis Mora. Encouraged by her sister, Genevieve, who had purchased a summer home there, Goth moved to a particularly rural

46

25 Adam Albright
QUOITS, 1908
Oil on canvas, 20¼ × 26¼ in.
Pennsylvania Academy of Fine Arts

spot. Marie Goth was primarily a portrait painter and a particularly noteworthy one. *Landscape with Cabins* is a rarity in her oeuvre (fig. 26).[55]

The Goth sisters brought Veraldo Cariani and Carl Graf to Brown County. Cariani had studied with Mora at the Art Students' League in New York and became a friend of fellow student, Marie Goth. After serving in World War I Cariani had difficulty adjusting to civilian life. Marie invited Cariani to visit Brown County and, like so many other artists, he became enamoured of the area. He remained, working for the father of the Goth sisters and building a studio on their property.

Cariani and Marie Goth maintained a liaison until his death in 1969. Genevieve Goth married Carl Graf, who was perhaps the most active and notable of this second generation of Brown County artists. Graf was born in Bedford, Indiana and studied at the John Herron School of Art, before going on to New York and the Art Students' League where he and Cariani became friends. He returned to the Midwest, and through Theodore Steele, came to know and appreciate Brown County, where he renewed his friendship with Cariani and met the Goth sisters.[56] After he married Genevieve they maintained a summer studio in

47

26 Marie Goth
LANDSCAPE WITH CABINS, n.d.
Oil on board, 20 × 16 in.
Jay and Ellen Carter Art and Antiques

Nashville, and a winter studio in Indianapolis. Graf and Cariani both painted in impasto and with brilliant colors, more vivid and dramatic than much of the work of the earlier Hoosier Group (fig. 27). Some of their paintings might be compared with the landscape painting of Edward Redfield and the Pennsylvania artists of the New Hope colony in the East. Graf painted a number of small, vivid landscapes in which one or another strong hue would dominate—brilliant yellows or rich greens (fig. 28). His art celebrated not only the essence of nature, but also the specifics of rural life of Brown countryside with its ramshackle dwellings (fig. 29) and farm people at their chores. Graf was more of a figure and genre painter than most of the Brown County artists; he also painted a number of vital Indianapolis urban scenes, in which its city inhabitants are shown coping with dynamic weather conditions. These works are reminiscent of those of The Ashcan School, or the later Fourteenth Street School,

48

27 Veraldo Cariani
THE FIRST SNOW, n.d.
Oil on board, 17 × 20 in.
Dr. and Mrs. Paul W. Elliot

in New York City.

Graf was also an active organizer among the artists of Brown County. He was first president of the Brown County Art Association which was formed in September 1926 for the purpose of holding public exhibitions to further the interests of the Brown County art colony. The organization was incorporated in April of 1927 and had, among its directors, Will Vawter, Louis Griffith and Ada Shulz. The Association renovated an old country store where exhibitions were held beginning in the fall of 1926. The effects of a nearby fire in 1953 caused the

Association to build a new gallery in Nashville, which in turn was destroyed by fire in 1966 and replaced in 1968. Some of the remaining founders of the Brown County group purchased the old Minor House in Nashville and renovated it in 1954 for a new non-profit organization, the Brown County Art Guild.[57]

INDIANA

landscape painting of the twentieth century has been so strongly associated with Brown County, and the area itself is so

attractive to artists and the general visitor alike, that one tends to overlook painters of great quality at work in other regions of the state which have their own distinctive natural beauty. South Bend, in the north of the state, has served as the artistic base for a number of first-rate artists, about whom more is being learned, thanks to the recent scholarship of Judy Oberhausen.[58]

One of the finest landscape painters associated with Indiana is Alexis Fournier. In addition to his connection with South Bend, Fournier spent part of each of seven

49

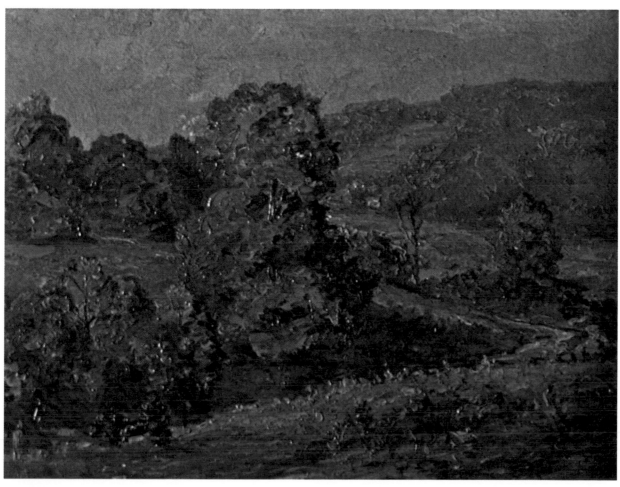

28 Carl Graf
AUTUMN LANDSCAPE, 1904
Oil on masonite, 17 × 22 in.
Indiana State Museum

years in Brown County beginning in 1927. Fournier's career and his art are complicated. He was born in St. Paul, Minnesota, and was one of Douglas Volk's best students in the art school in Minneapolis. Fournier's early paintings of Minneapolis are vivid, unpicturesque urban views.[59] He was then attached to an exploring expedition into San Juan County of Colorado, and went on into Utah, Arizona and New Mexico in 1891-92. In 1893 he worked on a panorama of the Cliff Dwellers of the Southwest for the Columbian Exposition in Chicago. After, he travelled to Paris, studying at the Academie Julian and developing a more poetic Barbizon style. He returned home in 1895, had a one-man show in Boston in 1898 and in Cincinnati in 1900, exhibiting mostly landscapes of Normandy.

Chicago was Fournier's base at this time, but in 1903 he met Elbert Hubbard who had developed the Roycroft Press and craft industries in East Aurora, New York and was invited there. Though Fournier was never officially involved with the organization, he painted landscapes for the decoration of the buildings, taught art classes, and was able to sell his art to visitors. In France, in the summer of 1907, he painted 20 canvases of the homes of the artists of the Barbizon school. These were painted in his current manner which was sympathetic with their own art. They brought Fournier great acclaim, which was enhanced by his publication in 1910 of *The Homes of the Men of 1830*.[60]

In 1923, Fournier married Cora May Ball of South Bend, and from

50

29 Carl Graf
BROWN COUNTY CELLAR HOUSE, n.d.
Oil on masonite, 22⅞ × 29⅞ in.
Mr. and Mrs. Richard E. Wise

then until her death in 1937, he spent part of the summers in East Aurora and the rest of the year in Indiana. Fournier painted some canvases around South Bend, but he worked principally in Brown County. By the 1920s, Fournier had moved away from the soft, tonal style he had developed in France and continued in East Aurora. Fournier's precise development at this time is unclear although the current researches of Rena Coen should clarify the matter. It would seem that, around 1920 or shortly thereafter, Fournier began to work more directly out-of-doors and to respond to bright sunlight and richer coloration; the paint was laid on in more flickering, somewhat Impressionist patterns. This later style would seem to have been present before Fournier began to visit and paint in Brown County, but he adapted it particularly successfully to the golden autumnal scenery there (fig. 30). In turn, the Impressionist-related work that Steele had painted there and the current manner of many of the Brown County painters in the late 1920s almost surely must have

51

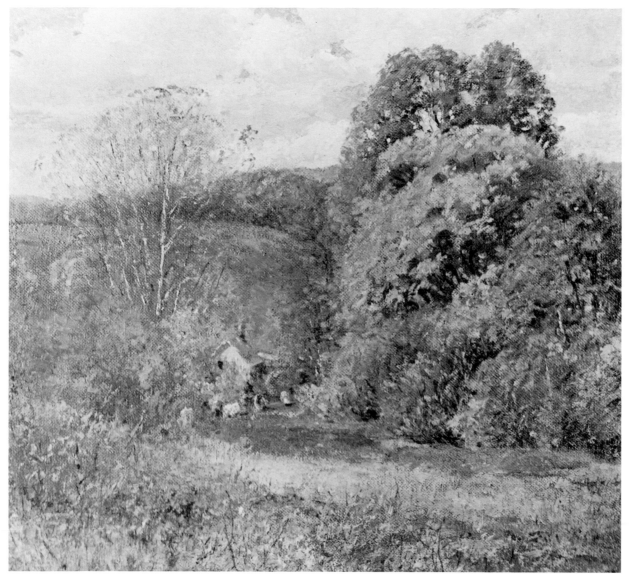

30 Alexis Fournier
AUTUMN IN BROWN COUNTY, n.d.
Oil on masonite, 24 × 26 in.
The Snite Museum of Art

reinforced Fournier's aesthetic.

A South Bend artist who made even more use of the local scenery was L. Clarence Ball.[61] Ball was born in Mount Vernon, Ohio but grew up in Goodland, Indiana where he developed his love of landscape painting. He moved to South Bend in 1878 and remained there for the rest of his life, with the exception of 1892-'93 when he was studying at the National Academy of Design in New York. Ball recorded the beauties of the marshes along the Kankakee River in northern Indiana (fig. 31)—recalling Hamlin Garland's fond observations of the light flooding the Kankakee Marshes—and the Saint Joseph River near Fort Wayne, when these were still the haunts of nature lovers. Ball also painted nearby at Diamond Lake, near Cassopolis, Michigan, where he had a summer home. Ball was adept in both oil painting and watercolor, but he was at his most masterful with watercolors which showed his virtuosity in achieving clarity and vivacity with the transparent washes.

52

31 L. Clarence Ball
KANKAKEE MARSH, n.d.
Watercolor, 5¾ × 8¾ in.
Mr. and Mrs. Frederick C. Elbel

A later landscape painter associated with South Bend was George Ames Aldrich.[62] Aldrich was born in Worcester, Massachusetts and studied at the Art Students' League with the great Impressionist, John Twachtman, before going to Paris to study at the academies Colarossi and Julian. Like many other American and foreign artists he worked for a while in Brittany; in his case near Quimperle. Aldrich continued to paint scenes of Breton villages when he returned to America and was working in New York in 1910 and then in Chicago. The scenes often featured rustic dwellings alongside flowing streams, capturing the sense of flow and the scintillation of rippling water in an extraordinary manner. His art was profoundly influenced by the work of Fritz Tháulow, the Norwegian Impressionist working primarily in France who was tremendously popular both in Europe and America. In 1922, Aldrich had an exhibition of 54 paintings at the Rotary Room of the Oliver Hotel in South Bend, and this led him to settle in the area and to teach at the Fine Arts Club. Aldrich's paintings of the Indiana landscape specifically are difficult to come by, but a number of his scenes are golden evocations of pastoral loveliness which would appear to be inspired by Indiana scenery if not direct transcriptions of it, and may bear more than incidental comparison with the autumnal work of Fournier (fig. 32).

The landscape painter most associated with Fort Wayne is

53

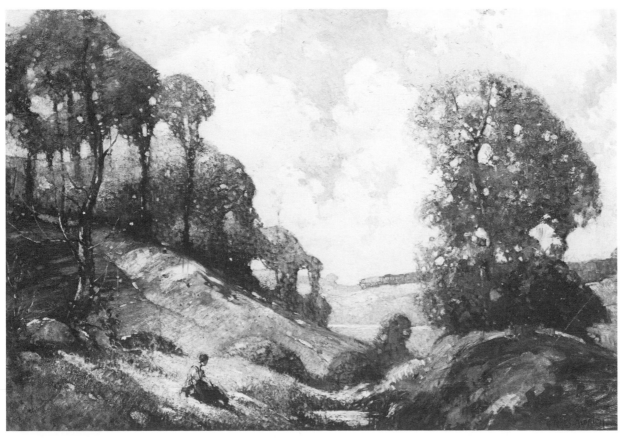

32 George Ames Aldrich
Untitled, n.d.
Oil on panel, 38 × 55¼ in.
The Snite Museum of Art

Homer Davisson, who was born in Blountsville, Indiana and studied at DePauw University in Greencastle, where he became interested in landscape painting. He went on to the principal art schools in the country, the Pennsylvania Academy where he worked with Thomas Anshutz, the Art Students' League, and the Corcoran School of Art in Washington, D.C. before he travelled to Germany, France and Holland. Davisson returned to Indiana and became director of the Fort Wayne Art School, where he gained renown as a teacher. Davisson was an active interpreter of Brown County, but he also painted the local scenery well. He even assumed the role of sculptor with his *Harmer's Crossing Monument* erected in 1908.

Given its proximity to the great midwestern metropolis, it is not surprising that Indiana dune country, at the south end of Lake Michigan, was a popular subject for Chicago painters. The best-known interpreter of the dunes was Frank Virgil Dudley, who, like Adolph Shulz, was a native of the little Wisconsin community of Delavan, and was also a pupil at the school of the Art Institute of Chicago. Dudley first saw the dune country in 1912, and in 1921 he sold out his art supply store in order to paint full time. He built a cabin in the dunes and divided his time between there and his Chicago studio.[63] The dunes had reverted to wilderness after the Indians had left, and following the Chicago fire, thousands of trees were cut from the area to rebuild the city.

54

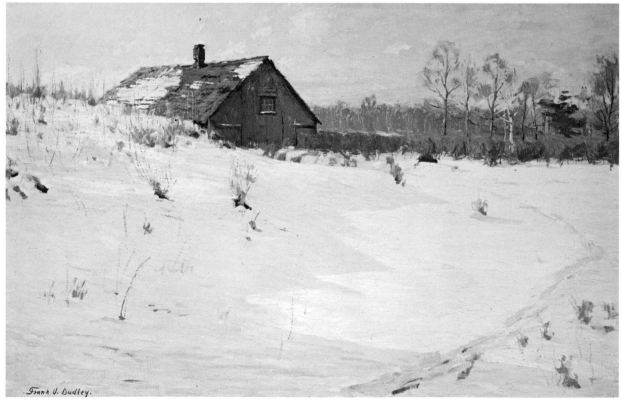

33 Frank Dudley
ONE WINTER'S AFTERNOON, n.d.
Oil on canvas, 37½ × 58½ in.
Union League Club of Chicago

The wilderness then reasserted itself and began to attract conservationists and naturalists. Dudley was a primary agent for the preservation of the dunes. The prize that he won at the Art Institute for his *Duneland* in 1921 enabled him to build his studio there. He painted the dunes during all seasons of the year (fig. 33) making the public "dune-conscious," and earning him the title of The Painter of the Dunes. In 1923 Indiana declared the dunes a State Park, and Dudley's cottage #108 was acquired by the State. Subsequently, Dudley arranged with the State of Indiana to exchange one painting a year for rent. The State thus preserved not only the dunes, but Dudley's pictorial rendition of them. The Indiana State Museum held an exhibition of Dudley's paintings of the dunes in March 1981.

THE GOLDEN

Age of Indiana landscape painting, then, is both a long and noble one. Other regions throughout America have recognized and celebrated their own scenic heritage in art adding to both the area's knowledge of its own heritage and to the nation's understanding of the various regional artistic accomplishments that collectively make up American art. Indiana has never been entirely oblivious to its rich artistic traditions but it has not, heretofore, been as aware of both the quality and the variety of the accomplishments of those who have interpreted the beauty of the State. Those achievements have only begun to be recognized beyond its borders. The Hoosier contribution—the interpretation of a distinctive American landscape within the precepts of modernism as it was understood at the turn-of-the-century—more than justified the optimism and prophecy of Hamlin Garland and his colleagues in 1894, and proved as well, the even older contention voiced by Theodore Steele in 1887 when he stated that:

"Landscape painting . . . is a modern art . . . The artist does not now sit in his studio and conjure up a weak suggestion of out-of-door life. He goes at once to nature herself, not as a mere copyist, for while he holds himself rigidly to truth or effect in atmosphere and light, his trained eye broadly generalizes, his imagination works with his hand, and the result, though it may be ideal, embodies the truth of reality. In fact it is the interpretation of Nature into the more impressive language of art."[64]

William H. Gerdts
New York
1983

FOOTNOTES

[1]"The Critical Triumvirate," *Five Hoosier Painters*, Chicago, 1894, p. 5

[2]William Crary Brownell, "The Younger Painters of America," *Scribner's Monthly*, Volume 20, May, 1880, p. 1.

[3]For Hays, Winter, Cox, Reed and Glessing, and, indeed, for Indiana art developments generally, earlier than the period covered in this essay, see the definitive study by Wilbur D. Peat, *Pioneer Painters of Indiana*, Chicago, and Crawfordsville, Indiana, 1954.

[4]For Snyder, including his sojourn into Brown County, see Peat, *op. cit.*, pp. 63-64, 80-81.

[5]For Steele's trip to Hanover, see Selma N. Steele, Theodore L. Steele and Wilbur D. Peat, *The House of the Singing Winds*, Indianápolis, 1966, p. 189. This is the seminal work on Steele, and almost all the biographical material on the artist that appears subsequently is taken from this source. For Steele, see also, Alfred M. Brooks, "The Art and Work of Theodore Steele," *The American Magazine of Art*, Volume 8, August, 1917, pp. 401-406.

[6]For the early organizations of art in Indianapolis in the late '70s, see Selma Steele, etc., *op. cit.*, pp. 13-14; Eva Draegert, "The Fine Arts in Indianapolis, 1875-1880," *Indiana Magazine of History*, Volume 50, June, 1954, pp. 109-113; Jacob Piatt Dunn, *Greater Indianapolis*, 2 Volumes, Chicago, 1910, Volume I, pp. 483-484: and William Forsyth, *Art in Indiana*, Indianapolis, 1916, pp. 9-10.

[7]Forsyth, *op. cit.*, pp. 10-12; and Mary Quick Burnet, *Art and Artists of Indiana*, New York, 1921, new ed., Evansville, Indiana, 1981, pp. 113-124. Forsyth and Burnet are the two principal studies of the history of Indiana art of the first two generations of Hoosier landscape painting.

[8]See footnote #6.

[9]Consult the *Catalogue of First Quarterly Exhibition of Indiana Art Association*, Indianapolis, 1878 including 203 pictures, plus a bric-a-brac exhibition

[10]Burnet, *op. cit.*, pp. 123-124.

[11]Selma Steele, etc., *op. cit.*

[12]These early copies after Lawrence and Stuart are today in the T. C. Steele State Memorial, Nashville, Indiana, housed in the studio that Steele built on his Brown County property in 1916.

[13]For J. Ottis Adams, in addition to the general sources previously cited, see John Alban Adams, *John Ottis Adams*, unpublished typescript, 1967, copy in the Indiana State Museum; *Catalogue of Paintings by John Ottis Adams, Memorial Exhibition*, Art Association of Indianapolis, 1927, with a brief forward by William Forsyth, and a list of all his paintings: and William E. Story, *John Ottis and Winifred Brady Adams, Painters*, (exhibition catalogue), Art Gallery, Ball State University, Muncie, 1976.

[14]The best study of The Society of American Artists is by Lois Marie Fink in *Academy, The Academic Tradition in American Art*, (exhibition catalogue), National Collection of Fine Arts, Washington, D.C., 1975, pp. 79-90.

[15]Michael Quick is presently completing a doctoral dissertation for Yale University on the American artists who studied in Munich. See also Michael Quick and Eberhard Ruhmer, *Munich & American Realism in the 19th Century* (exhibition catalogue), E. B. Crocker Art Gallery, Sacramento, California, 1978; and Aloysius George Weimer, "The Munich Period in American Art," Ph.D. dissertation, unpublished, University of Michigan, 1940. Most pertinent for the Hoosier painters there in the '80s is Mary E. Steele, *Impressions*, Indianapolis, 1893, based upon a talk presented before The Portfolio Club, and Forsyth, *op. cit.*, pp. 13-14.

[16]Forsyth, *op. cit.*, p. 15.

[17]The standard work on J. Frank Currier is Nelson C. White, *The Life and Art of J. Frank Currier*, New York, 1936. See also Mary Steele, *op. cit.*

[18]Mary Steele, *op. cit.*, (unpaginated)

[19]For the early years of the Indianapolis Art Association, see Eva Draegert, "The Fine Arts in Indianapolis, 1880-1890," *Indiana Magazine of History*, Volume 50, December, 1854, pp. 325-327: Sister M. Dolorita Carper, O.S.F., "A History of the John Herron Art Institute;" Masters thesis, Butler University, Indianapolis, 1947; and May Wright Sewall et al, *Art Association of Indianapolis, Indiana, A Record, 1883-1906*, Indianapolis, 1906.

[20]Leland G. Howard, *Otto Stark 1859-1926*, (exhibition catalogue), Indianapolis Museum of Art, 1977

[21]Georgia Fraser, "Otto Stark and his Work," *Art Education*, Volume 5, December, 1898, p. 108.

[22]William H. Gerdts, *American Impressionism*, (Exhibition catalogue), The Henry Art Gallery, University of Washington, Seattle, 1980, pp. 103-106, was the first to consider Hoosier developments within the larger context of American Impressionism. See also Judy Oberhausen, *Impressionistic Trends in Hoosier Painting*, (exhibition catalogue), Art Center, Inc., South Bend, 1979.

[23]Forsyth, *op. cit.*, p. 16.

[24]All these appeared in *Modern Art*: Theodore C. Steele, "Impressionalism," Volume 1, Winter, 1893, unpaginated: William Forsyth, "Some Impressions of the Art Exhibit at the Fair—III," Volume 1, Summer, 1893, unpaginated; Otto Stark, "The Evolution of Impressionism," Volume 3, Spring, 1895, pp. 53-56. Steele and Forsyth published other articles in the magazine, unrelated to American or Hoosier Impressionism, and

another local painter, Susan Ketcham, published an article on the American Impressionist, Robert Vonnoh.

[25]For a brilliant analysis of *Modern Art*, there is Eleanor Phillips Brackbill, "*Modern Art*: An American Magazine of the 1890's,", a paper prepared in a seminar on Early American Art Criticism, Graduate School of the The City University of New York, Fall, 1981, unfortunately unpublished.

[26]*The Art Amateur*, Volume 32, March, 1895, p. 107.

[27]Hamlin Garland, *Roadside Meetings*, New York, 1930, pp. 30-31.

[28]"Greta," "Boston Art and Artists," *The Art Amateur*, Volume 17, October, 1887, p. 93.

[29]Hamlin Garland, *Crumbling Idols: 12 Essays on Art*, 1894, New edition, Cambridge, Massachusetts, 1960, pp. 97-110.

[30]On the activities of the Central Art Association, see Russell Lynes, *The Tastemakers*, New York, 1954, pp. 151-156.

[31]"The Critical Triumvirate," *Impressions on Impressionism*, Chicago, 1894, passim.

[32]"The Critical Triumvirate," *Five Hoosier Painters*, Chicago, 1894, passim. This was reproduced, in somewhat shortened form, but with illustrations, in *The Arts* (later, *Arts for America*) Volume 3, January, 1895, pp. 178-184.

[33]*op. cit.*, passim.

[34]Harriet Monroe, "Chicago Letter," *The Critic*, Volume 22, December 29, 1894, p. 450.

[35]Hamlin Garland, *United Annual Exhibition. Palette Club. Cosmopolitan Art-Club*, The Art Institute of Chicago, 1895, introduction, unpaginated.

[36]*A Collection of Oil Paintings by Mr. T. C. Steele and Mr. J. Ottis Adams*, Saint Louis Museum of Fine Arts, 1896; and *Catalogue of Special Exhibitions, December, 1906. First Annual Exhibition of Selected Paintings by Western Artists*, The Saint Louis Museum of Fine Arts, 1906.

[37]For Richmond, see Ella Bond Johnston, *The Art Movement in Richmond*, Richmond, 1953; and *Art in Richmond: 1898-1978*, Catalogue of the permanent collection of the Art Association of Richmond, Indiana, 1978.

[38]" 'The Richmond Group' of Painters," *The Art Interchange*, Volume 51, October, 1903, pp. 85-86.

[39]For Wayman Adams, see Helen Comstock, "Portraits of Wayman Adams," *International Studio*, Volume 77, May, 1923, pp. 87-91; Rose Henderson, "Wayman Adams—Portrait Painter," *American Magazine of Art*, Volume 21, November, 1930, pp. 640-648: and Wilbur D. Peat, *Wayman Adams, N.A. 1883-1959*, (exhibition catalogue), The John Herron Art Museum, Indianapolis, 1959.

[40]For "The House of the Singing Winds," see the essay by Selma N. Steele, in the book she co-authored of that name, pp. 55-167: and Alfred Mansfield Brooks, "The House of the Singing Winds," *American Magazine of Art*, Volume 11, February, 1920, pp. 139-141.

[41]*A Special Collection of Paintings by Theodore C. Steele*, St. Louis Museum of Fine Arts, 1907: *Retrospective Exhibition of the paintings of Theodore C. Steele*, Art Association of Indianapolis, 1910: *Memorial Exhibition Theodore C. Steele 1847-1926*, with a foreword and descriptions by George Chambers Calvert (and a listing of works not in the exhibition), Art Association of Indianapolis, 1926. No catalogue of the 1920 exhibition has presently been located, but it is amply described in the many newspaper clippings on file in the Library of the Indianapolis Museum of Art.

[42]Mary Quick Burnet, "Indiana University and T. C. Steele," *American Magazine of Art*, Volume 15, November, 1924, pp. 587-591.

[43]See the bibliography for Steele's published lectures; Selma N. Steele, et al, *op. cit.*, reports on his lecturing on many other occasions. Steele lectured extensively, and positively, on the subject of Impressionism when this was particularly topical

at the end of the nineteenth century; his counterpart, in opposition and derision, was the watercolorist, F. Hopkinson Smith, and they are known to have lectured, in a sense, viz-a-viz one another. Smith's Impressionist lecture is known today in several forms.

[44]The public library in Delavan has extensive files of clippings of the art activities in that community, including the summer classes taught by John Vanderpoel. See especially Gertrude Stiles, "The Sketch Class at Delavan, Wisconsin," The Art Interchange, Volume 39, September, 1897, pp. 55-56; reprinted in the Delavan Enterprise, September 9, 1897.

[45]Vanderpoel awaits modern critical attention to his role both as artist and teacher. See Esther Sparks, "A Biographical Dictionary of Painters and Sculptors in Illinois, 1808-1945," unpublished Ph.D. dissertation, Northwestern University, 1971, p. 648. Also, Thomas Wood Stevens, "John H. Vanderpoel and his Work," The Inland Printer, Volume 47, August, 1911, pp. 589-593.

[46]John H. Vanderpoel, "Delavan and its Environments," Delavan Enterprise, August 10, 1899.

[47]For Shulz see Marian A. White, "A Landscape Painter of the Middle West," Arts and Decoration, Volume 2, July, 1912, pp. 332-333; A Retrospective Exhibition of Paintings and Drawings of Adolph Robert Shulz, Indiana State Museum, Indianapolis, 1971; and "Delavan's Adolph Shulz Becomes Prominent Artist," Delavan Enterprise, February 10, 1972, pp. 3B-4B.

[48]Adolph Robert Shulz, "The Story of the Brown County Art Colony," Indiana Magazine of History, Volume 31, December, 1935, p. 284.

[49]See the reminiscences of Harry L. Engle, " 'Hoosier Salon' Recalls Old Days to Club Members," The Palette & Chisel, Volume 1, March, 1925, pp. 1-2.

[50]Shulz, op. cit., pp. 282-289; Shulz' article on Brown County is an important, authoritative source for the history of this significant Hoosier landscape development.

[51]See Brown County Art and Artists, published by the Psi Iota Xi Sorority, Nashville, Indiana, 1971; also, Harry L. Engle, "Now Then—," The Palette & Chisel, Volume 1, November, 1927, p. 4.

[52]For Albright see: Marian A. White, "Adam Emory Albright—Painter of Child Life in the Country," Fine Arts Journal, Volume 13, July, 1902, pp. 312-319; Henry E. Willard, "Adam Emory Albright, Painter of Children," Brush and Pencil, Volume 12, April, 1903, pp. 1-13; Gardner Teall, "The Sunny Years: Illustrated by Adam Emory Albright's Paintings of Childhood," The Craftsman, Volume 19, November, 1910, pp. 140-148; Teall also wrote on Albright earlier in The Craftsman, in the article, "Our Western Painters: What Chicago is Doing Toward the Development of a Vital National Spirit in American Art," Volume 15, November, 1908, p. 152; Minnie Bacon Stevenson, "A Painter of Childhood," The American Magazine of Art, Volume 11, October, 1920, pp. 432-434. Albright himself wrote an article on "Outdoor Painting," for Palette and Bench, Volume 1, July, 1909, which was illustrated by his own works as was the preceding article by his colleague, Charles C. Curran, "Class in Oil Painting," a serialized column, see pp. 238-242 in that issue. There are also the many exhibition catalogues of his exhibitions held at The Art Institute of Chicago and elsewhere.

[53]For Krafft and The Society of Ozark Painters, see Lena McCauley, "A Painter Poet of the Ozarks," Fine Arts Journal, Volume 10, October, 1916, pp. 465-472, especially; also, V. E. Carr, "Carl R. Krafft," American Magazine of Art, Volume 17, September, 1926, pp. 474-480.

[54]Rudolph F. Ingerle, "A Painters' Paradise and Its Lure," The Palette & Chisel, Volume 8, May, 1931, pp. 1-2.

[55]See the brochure put out by the Brown County Art Guild Inc. presenting The Memorial Room of Marie Goth, Veraldo J. Cariani, Genevieve and Carl Graf, Nashville, Indiana, 1978 (?).

[56]See Josephine A. Graf, "The Brown County Art Colony," Indiana Magazine of History, Volume 35, December, 1939, pp. 305-370. She was the sister of Carl Graf and writes on her brother, Cariani and the Goth sisters on pp. 368-369.

[57]See Brown County Art and Artists, op. cit., passim, unpaginated.

[58]Judy Oberhausen, Impressionistic Trends . . ., op. cit., and also her catalogue of The Work of George Ames Aldrich, L. Clarence Ball & Alexis Jean Fournier in South Bend Collections, Art Center, Inc., South Bend, 1982.

[59]Rena Neumann Coen, Painting and Sculpture in Minnesota 1820-1914, Minneapolis, 1976, pp. 112-119.

[60]Besides Fournier's own The Homes of the Men of 1830, New York, 1910, there is a fair amount of literature about him written in his own time. Besides various exhibition catalogues, and a wealth of newspaper clippings, see: E. J. Rose, "Alexis J. Fournier," Brush and Pencil, Volume 4, August, 1899, pp. 243-247; "Alexis J. Fournier—Minnesota Painter of Exceeding Versatility," Fine Arts Journal, Volume 14, March, 1903, pp. 82-87; "Alexis J. Fournier's Crepuscle," Fine Arts Journal, Volume 21, July, 1909, pp. 53-54; Thomas Shrewsbury Parkhurst, "The Art of Alexis Jean Fournier," Fine Arts Journal, Volume 34, March, 1916, pp. 128-133; "A Monotype Party at Alexis Fournier's," The Buffalo Artists' Register, edited by Lee F. Heacock, Volume 1, 1926, pp. 105-108; and recently, the exhibition catalogue, with essays by Austin M. Fox and Miriam Hubbard Roelofs, Alexis Jean Fournier, A Barbizon in East Aurora, Burchfield Center, Buffalo, New York, 1979. What there is not, is a consideration of Fournier in Indiana, except for Oberhausen's perceptive but brief accounts of his activities there.

[61]Oberhausen, The Work of . . ., op. cit.

[62]op. cit.

[63]Sparks, op. cit., pp. 139, 162;" Frank Dudley, Indiana Dunes Painter, Dies," Chicago Daily Tribune, March 7, 1957; "The Rent for Cottage 108," History on the Move–Indiana State Museum, Volume 10, March, 1981.

[64]Selma N. Steele, et al, op. cit., p. 36, quoting an interview with Steele in the Indianapolis News of February 19, 1887, shortly after he had sold pictures in New York and Boston, and when The Oaks at Vernon was then on his easel.

BIBLIOGRAPHY

This is not a "Selective" bibliography. The author has incorporated here all the significant material he has used to choose the paintings in the exhibition, to learn the fundamentals of Indiana landscape painting of the period, and to compose the essay, and the publications here listed should prove useful to all who wish to pursue the subject further. Material not included here is the wealth of exhibition catalogs for shows in which the Hoosier paintings participated but which were not paramount to this study, and the clippings from the newspaper files in the many museums and public libraries which house such material. Undoubtedly there are omissions here, for which the author apologizes—and of which he hopes to learn in the future.

Adams, John Alban, John Ottis Adams, manuscript typescript, 1967, collection of the Indiana State Museum, Indianapolis.

Albright, Adam, Emory, For Art's Sake, Warrenville, Illinois, 1953.

Albright, Adam Emory, "Outdoor Painting," Palette and Bench, Volume 1, July, 1909, pp. 241-242.

"Alexis J. Fournier Minnesota Painter of Exceeding Versatility," Fine Arts Journal, Volume 14, March, 1903, pp. 82-87.

American Art in the Union League Club of Chicago A Centennial Exhibition, Union League Club, Chicago, et al, 1980.

Art in Richmond: 1898-1978, Catalogue of the permanent collection of the Art Association of Richmond, Indiana, 1978.

Biographical Sketches of Indiana Artists Whose Works May Be Viewed in Indianapolis Office of Ernst & Ernst, Indianapolis (?), n.d.

Bowles, Joseph Moore, "Messrs. Steele and Forsyth," Modern Art, Volume 1, Spring, 1893, unpaginated.

Brackbill, Eleanor Phillips, "Modern Art: An American Magazine of the 1890's,", unpublished term paper in a seminar on Early American Art criticism, Graduate School of the City University of New York, Fall, 1981.

Brooks, Alfred Mansfield, The Art and Work of Theodore Steele," American Magazine of Art, Volume 8, August, 1917, pp. 401-406

Brooks, Alfred Mansfield, "The House of the Singing Winds," American Magazine of Art, Volume 11, February, 1920, pp. 139-41

Brown County Art and Artists, Nashville, Indiana, 1971.

Burnet, Mary Quick, Arts and Artists of Indiana, New York, 1921, new edition, Evansville, Indiana, 1981

Burnet, Mary Quick, "Indiana University and T.C. Steele," American Magazine of Art, Volume 15, November, 1924, pp. 587-591

Calvert, George Chambers, Memorial Exhibition Theodore C. Steele 1847-1926, Art Association of Indianapolis, 1926.

Carper, Sister M. Dolorita, O.S.F., "A History of the John Herron Art Institute," Masters Thesis, Butler University, Indianapolis, 1947.

Catalogue of First Quarterly Exhibition of Indiana Art Association, Indianapolis, 1878

A Century of Indiana Art 1800-1900, (exhibition catalogue Jane and Henry Eckert Antiques, Westfield, Indiana, 1982.

A Collection of Oil Paintings by Mr. T.C. Steele and Mr. J. Ottis Adams (exhibition catalogue), Saint Louis Museum of Fine Arts, 1896.

Comstock, Helen, "Portraits of Wayman Adams," International Studio, Volume 77, May, 1923, pp. 87-91.

Cooke, Charles H., "C. Curry Bohm Landscape Painter," *The Palette & Chisel*, Volume 5, September, 1928, pp. 1-2.

"A Critical Triumvirate," (Hamlin Garland, Lorado Taft, Charles Francis Browne), *Five Hoosier Painters*, Chicago, 1894.

"A Critical Triumvirate" (Hamlin Garland, Lorado Taft, Charles Francis Browne), *Impressions on Impressionism*, Chicago, 1894.

Curran, Charles C., "Class in Oil Painting," *Palette and Bench*, Volume 1, July, 1909, pp. 238-239, (utilizing as examples and illustrations the work of Adam Emory Albright)

The Dailey Family Memorial Collection of Hoosier Art, Indiana University, Bloomington, n.d.

The Dailey Family Memorial Collection of Paintings, (exhibition catalogue) Indiana University, Bloomington, 1960

"Delavan's Adoph Shulz Becomes Prominent Artist," *Delavan* (Wisconsin) *Enterprise*, February 10, 1972, pp. 3B-4B

Draegert, Eva, "The Fine Arts in Indianapolis, 1875-1880," *Indiana Magazine of History*, Volume 50, June, 1954, pp. 105-118.

Draegert, Eva, "The Fine Arts in Indianapolis, 1880-1890," *Indiana Magazine of History*, Volume 50, December, 1954, pp. 321-348.

Dunn, Jacob Piatt, *Greater Indianapolis*, 2 Volumes, Chicago, 1910

Engle, Harry L., "'Hoosier Salon' Recalls Old Days to Club Members," *The Palette & Chisel*, Volume 1, March, 1925, pp 1-2.

Engle, Harry L., "Now Then—," (concerning Brown County art), *The Palette & Chisel*, Volume 1, November, 1927, p. 4.

Exhibition of Selected Paintings by Western Artists, St. Louis Musem of Fine Arts, 1906.

The First Hundred Years of Indiana Painting, (exhibition catalogue), Herron Museum of Art, Indianapolis, 1966.

"Five Hoosier Painters," *The Arts*, Volume 3, January, 1895, pp. 179-184.

Forsyth, William, *Art in Indiana*, Indianapolis, 1916.

Forsyth, William, *Memorial Exhibition of the Paintings of John Ottis Adams*, John Herron Art Institute, Indianapolis, 1927.

Forsyth, William, "Secession," *Modern Art*, Volume 2, Autmn, 1894, no pagination.

Forsyth, William, "Some Impressions of the Art Exhibit at the Fair—II . . . Impressionism . . .," *Modern Art*, Volume 1, Summer, 1893, unpaginated.

Fournier, Alexis Jean, *The Homes of the Men of 1830*, New York, 1910.

Fox, Austin S., *Alexis Jean Fournier A Barbizon in East Aurora*, (exhibition catalogue), Burchfield Center, State University College at Buffalo, 1979.

Fraser, Georgia, "Otto Stark and his Work," *Art Education*, Volume 5, December, 1898, pp. 106-108.

Garland, Hamlin, *Crumbling Idols; 12 Essays on Art*, 1894, new edition, Cambridge, Massachusetts, 1960.

Garland, Hamlin, *United Annual Exhibition. Palette Club. Cosmopolitan Art-Club*, (exhibition catalogue), The Art Institute of Chicago, 1895.

Gerdts, William H., *American Impressionism*, (exhibition catalogue), The Henry Art Gallery, University of Washington, Seattle, 1980.

Graf, Josephine A., "The Brown County Art Colony," *Indiana Magazine of History*, Volume 35, December, 1939, pp. 365-370.

Graubner, Ernest Leslie, *T.C. Steele Indiana Painter 1847-1926*, (exhibition catalogue), Fort Wayne Museum of Art, 1967.

Henderson, Rose, "Wayman Adams—Portrait Painter," *American Magazine of Art*, Volume 21, November, 1930, pp. 640-648.

Hoosier Artists: Family & Friends, Selected from the private collection of Mr. and Mrs. Richard Wise, Union City, Indiana, (exhibition catalogue), Indiana Art Circuit, 1980.

Howard, Leland G., *Otto Stark 1859-1926*, (exhibition catalogue), Indianapolis Museum of Art, 1977.

Indiana Art in the Permanent Collection of the John Herron Art Museum, Indianapolis, 1951.

Johnston, Ella Bond, *The Art Movement in Richmond*, Richmond, Indiana, 1953.

Ketner, Joseph D., II, *Pioneer Hoosier Painting*, (exhibition catalogue), Fort Wayne Museum of Art, 1982.

Kysela, John D., S.J., "The Critical and Literary Background for a study of the Development of Taste for 'Modern Art' in America, from 1880-1900," unpublished M.A. thesis, Loyola University, 1964.

Lazarus, Diane Gail, and Marilyn Reed Holscher, *Mirages of Memory: 200 Years of Indiana Art*, (exhibition catalogue), Indianapolis Museum of Art, 1976.

Memorial Exhibit of the Paintings of John Ottis Adams, Ball State Teachers College, Muncie, 1930.

Memorial Exhibition of the work of Otto Stark 1859-1926, Art Association of Indianapolis, 1926, (typescript)

The Memorial Room of Marie Goth, Veraldo J. Cariani, Genevieve and Carl Graf, Brown County Art Guild Inc., Nashville, Indiana, n.d., (1978 ?)

Monroe, Harriet, "Chicago Letter," *The Critic*, Volume 22, December 29, 1894, pp. 449-450.

Oberhausen, Judy, *Impressionistic Trends in Hoosier Painting*, (exhibition catalogue,) Art Center, Inc., South Bend, Indiana, 1978.

Oberhausen, Judy, *The Work of George Ames Aldrich, L. Clarence Ball & Alexis Jean Fournier in South Bend Collections*, (exhibition catalogue), Art Center, Inc., South Bend, 1982.

150 Years of Indiana Art, (exhibition catalogue), Ball State University Art Gallery, Muncie, Indiana, 1966.

Parkhurst, Thomas Shrewsbury, "The Art of Alexis Jean Fournier," *Fine Arts Journal*, Volume 34, March, 1916, pp. 128-133.

Peat, Wilbur D., *Pioneer Painters of Indiana*, Chicago, Illinois and Crawfordsville, Indiana, 1954.

Peat, Wilbur D., *Wayman Adams, N.A. 1883-1959*, (exhibition catalogue), The John Herron Art Museum, Indianapolis, 1959.

Phillips, Clifton J., *Indiana in Transition The Emergence of an Industrial Commonwealth 1880-1920*, Indianapolis, 1968.

Rabb, Kate M. and William Herschell, *Indianapolis and Marion County*, Dayton, Ohio, 1924.

A Retrospective Exhibition of Paintings and Drawings by Adolph Robert Shulz, Indiana State Museum, Indianapolis, 1971.

Retrospective Exhibition of the paintings of Theodore C. Steele, Art Association of Indianapolis, 1910.

" 'The Richmond Group' of Painters," *The Art Interchange*, Volume 51, October, 1903, pp. 85-86.

Rose, E.J., "Alexis J. Fournier," *Brush and Pencil*, Volume 4, August, 1899, pp. 243-247.

Sewall, May Wright, Laura Fletcher Hodges and Carl H. Lieber, *Art Association of Indianapolis Indiana A Record 1883-1906*, Indianapolis, 1906.

Shulz, Adolph Robert, "The Story of the Brown County Art Colony," *Indiana Magazine of History*, Volume 31, December, 1935, pp. 282-289.

Sparks, Esther, "A Biographical Dictionary of Painters and Sculptors in Illinois 1808-1845, "Ph. D. dissertation, Northwestern University, Evanston, 1971. *A Special Collection of Paintings by Theodore C. Steele*, (exhibition catalogue), St. Louis Museum of Fine Arts, 1907.

Stark, Otto, "The Evolution of Impressionism," *Modern Art*, Volume 3, Spring, 1895, pp. 53-46.

Steele, Mary E., *Impressions*, Indianapolis, 1893.

Steele, Selma N., Theodore L. Steele, and Wilbur D. Peat, *The House of the Singing Winds: The Life and Work of T.C. Steele*, Indianapolis, 1966.

(Steele, Theodore C., a short notice), *The Art Amateur*, Volume 32, March, 1895, p. 107.

Steele, Theodore C., "The Art of Seeing Beautifully," *The Fort Wayne Journal-Gazette*, December 8, 1925, p. 2.

Steele, Theodore C., "Impressionalism," *Modern Art*, Volume 1, Winter, 1893, unpaginated.

Steele, Theodore C. "The Mark of the Tool," *Modern Art*, Volume 2, Spring, no pagination.

Steele, Theodore C., *The Steele Portfolio*, Indianapolis, 1890.

Stevens, Thomas Woods, "John H. Vanderpoel and His Work," *The Inland Printer*, Volume 47, August, 1911, pp. 689-693.

Stevenson, Minnie Bacon, "A Painter of Childhood " (Adam Emory Albright,) *American Magazine of Art*, Volume 11, October, 1920, pp. 432-434.

Stiles, Gertrude, "The Sketch Class at Delavan, Wisconsin," *The Art Interchange*, Volume 39, September, 1897, pp. 55-56.

Story, William E., *Drawings by the Hoosier Group*, (exhibition catalogue), Art Gallery, Ball State University, Muncie, Indiana, 1976.

Story, William E., *John Ottis and Winifred Brady Adams, Painters*, (exhibition catalogue), Art Gallery, Ball State University, Muncie, 1976.

Teall, Gardner, "Our Western Painters: What Chicago is Doing toward the Development of a Vital National Spirit in American Art," *The Craftsman*, Volume 15, November, 1908, pp. 139-153.

Teall, Gardner, "The Sunny Years: Illustrated by Adam Emory Albright's Paintings of Childhood," *The Craftsman*, Volume 19, November, 1910, pp. 140-148.

Vanderpoel, John H., "Delavan and its Environments," *Delavan* (Wisconsin) *Enterprise*, August 10, 1899.

White, Marian A., "Adam Emory Albright—Painter of Child Life in the Country," *Fine Arts Journal*, Volume 13, July, 1902, pp. 312-319.

White, Marian A., "A Landscape Painter of the Middle West The Work of Adolph R. Shulz," *Arts and Decoration*, Volume 2, July, 1912, pp. 332-333.

Willard, Henry E., "Adam Emory Albright, Painter of Children," *Brush and Pencil*, Volume 12, April, 1903, pp. 1-13.

William Forsyth (1854-1935), (exhibition catalogue), Jane & Henry Eckert Antiques, Westfield, Indiana, n.d.

Ye Works of Ye Hoosier Colony in Munich Illustrated from The Originals by The Bohe Club, (exhibition catalogue) Indianapolis, 1885.

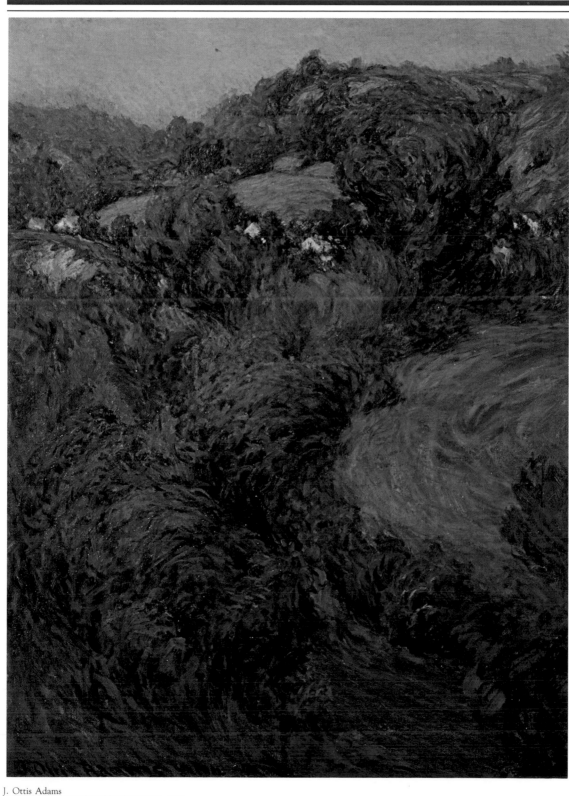

J. Ottis Adams
ACROSS THE VALLEY-BROOKVILLE, 1904
Oil, 32 x 27 in.
Fort Wayne Museum of Art

Geography—to paraphrase Sigmund Freud *in extremis*—is not destiny. *Indiana Influence* assembles over two dozen contemporary artists with significant ties to the State of Indiana, and what inferences can be drawn from this assembly?

None, really. The presence of each affirms only that Indiana is a place—or a collection of places—that can nurture artistic impulses. That some of the artists included in the exhibit currently inhabit Indiana bespeaks an active art scene in the State. The

INDIANA'S MODERN LEGACY

majority of artists included in the show, however, no longer live in the Indiana towns of their births, childhoods, and/or educations.

The artists here all have reputations that extend well beyond the State. Every one, whether currently residing in Indiana or not, has garnered recognition in the national—and frequently international—art capitals. It has helped that one of these capitals is Chicago, the nearby hub of the Calumet industrial region along the south shore of Lake Michigan. It has also helped that a long-standing tradition of support for visual art thrives in Indianapolis and Bloomington, as well as at Indiana's outstanding private universities, and in magical

places like Columbus, a town dedicated to celebrating art's sister discipline, architecture. Indiana is no cultural backwater; the Hoosier roots of so many of today's leading artists is not just happy accident.

Still, these artists have had to leave Indiana to gain recognition beyond Indiana or, at the very least, have had to gain that recognition beyond Indiana in order to perpetuate that recognition. But this is changing too. The increasingly lively activities of museums around the state are putting those museums on the national map, or are reaffirming and enlarging their already established places. The move of the Fort Wayne Museum of Art to its new building is only the latest demonstration of sensitivity and commitment on the part of Hoosier art makers and art supporters. This exhibition, therefore, celebrates not only the new Fort Wayne Museum of Art, but the old, yet growing, spirit of artistic vitality in Indiana.

This vitality extends far deeper than the few Indiana artists in this exhibition who are well-known beyond the State. There are numerous artists with Hoosier roots who may merit

similar acclaim, but who have elected not to seek it, or have not been able to find it. Art-world recognition, after all, is much more than the talented getting their due; unfortunately, but inevitably, such recognition is more a matter of the right person being in the right place at the right time than it is of just being the right person. While researching this show, I came across the work of dozens of contemporary artists who merit exposure beyond the local museums, school galleries, artist-run spaces, and regional annual shows that support local reputations. I was continually diverted from my main task by the opportunity to peruse catalogs from recent Indiana Artists Shows at the Indianapolis Museum of Art, or the Indiana Artists Showcase catalogs from Purdue. As has been my experience in states as diverse as Virginia, Ohio, Louisiana, and Colorado, I discovered that there is a network of statewide support that sustains some serious and original talent.

S UPPORTING

local talent is not, alas, the purpose of this exhibit, although *Indiana Influence* unequivocally celebrates the strength of art in Indiana. Indeed, this collection stands as irrefutable testimony to the artistic energy native to the State. Some of these artists merit their broad recognition because of their Indiana experience. Others, admittedly, are artists despite that experience. In the latter instance, *despite* is a form of *because* for cultural adversity may well strengthen resolve. Even those

artists who told me of their youthful desire to leave Indiana still recall their early life with the uncomplicated fondness of childhood memories for the places and spaces of his or her youth. And this fondness is not incidental to the perceptions informing the work of the artists.

No style or attitude predominates among the three generations represented in this exhibit. There is a marked surfeit of sculptors; might this indicate something about Indiana as a source of perception, a source of a particular sensibility or range of sensibilities? Does the industrial northern part of the state impart a feel for steel? Does the sense of *the land* farther south, in the area of farming and quarrying, provoke a sensitivity for stone or wood?

None of the sculptors I talked with associates the impulses behind his work (interestingly, the sculptors are all male) with his experiences in the state. Perhaps it is coincidence. Perhaps it is the residue of some tradition of stone carving and/or metal casting that has suffused almost undetected through Indiana's educational system. Perhaps it is just some ineffable inflection of the Hoosier spirit.

The basic criteria for inclusion in this exhibition have already been indicated: substantial ties to the State of Indiana and an

David Smith
Untitled (gestural sculpture), 1937
Oil on canvas, 26⅞ x 34¹⁵/₁₆ in.
Candida and Rebecca Smith

61

artistic reputation established nationally or internationally, no matter what the artist's current residence and aesthetic milieu. Further, the work here is limited to painting, sculpture, and large-scale mixed media; photography and graphic media (including more intimate forms of drawing) have not been included, although, of course, there are Hoosier-bred artists and Indiana residents who have excelled at these media and formats as well.

What defines 'substantial ties' to Indiana? It is not merely being born here; it is not just teaching here for a few years; it is not only living here for half a decade, previous to or during one's life as an artist. It is a combination of any of these and other qualifications, a combination that adds up to a demonstrably profound association with the State. The artists here who teach or have taught at Indiana schools have done so for something like two decades—one fourth to one third of a normal life's duration. These artists who have studied at Indiana schools have also grown up in the State, and/or have stayed to teach and work here. And an anomalous case like Isamu Noguchi is not so anomalous when you consider which four years of his life he spent in Indiana: the four years at the end of his adolescence during which he decided his calling was sculpture and he set out to train for that calling. Those four years mean more to Noguchi than a decade of teaching at Notre Dame or the University of Indiana might mean to a mature professional who then goes on to teach elsewhere. What makes the artists here unarguably Hoosier is not just resume data but biographical substance.

Inevitably, other renowned artists with substantial ties to Indiana have been erroneously omitted, or were deliberately not included because of prior limitations that restrict the extent of supposedly omnibus surveys like this one. Exclusion from this compilation is not a mark of unworthiness, but inclusion is a reaffirmation of distinction. Some artists here hardly need such a reaffirmation; their caps are so full of feathers there is barely room for one more. Others, however, are not so widely heralded, although they are all recognized in at least a few important art centers around the world.

THERE IS NOT much qualitative variety here. The real variety is in the diversity of style, approach, and attitude. In terms of what these artists do, this is certainly a bunk full of strange bedfellows. Although relationships among some of the artists may be apparent, most of these are accidental. If, for instance, the figural paintings of longtime Indiana University colleagues Robert Barnes and James McGarrell are stylistically connected, can one explain the similarities in materials and material combinations practiced by Isamu Noguchi and James Huntington as anything more than coincidence, knowing that the younger Huntington developed his stone-metal combinations with virtually no knowledge of those of the older master? And what about the unlikely, pun-loving trio of

Bruce Nauman, Kay Rosen and William T. Wiley? If Wiley made it possible for Nauman to follow his own Funk-antiformal tendencies out in the San Francisco Bay Area, how could that have affected the decidedly non-Funk conceptualist Rosen back in Gary?

These are relationships perhaps clarified, perhaps obscured, by conjoining these 27 artists according to a rubric that apparently has nothing to do with their art. In stylistic terms, it certainly does not. This show proves there is no *Ecole d'Indiana.* But in less concrete terms, on the level of the spiritual, and perhaps invisible, there is a little bit of Indiana in every work.

This is, in any case, a homecoming for many Indianans. What makes one of them a Hoosier may be entirely different from what makes the other one so, but there is something that makes every one a product, at least partially, of the State. Likewise, what makes one of them an artist may be directly contrary to what makes the next one an artist. But there is something that makes every one an artist whose accomplishment has managed to attract and maintain national attention and respect.

Peter Frank
New York
August 1983

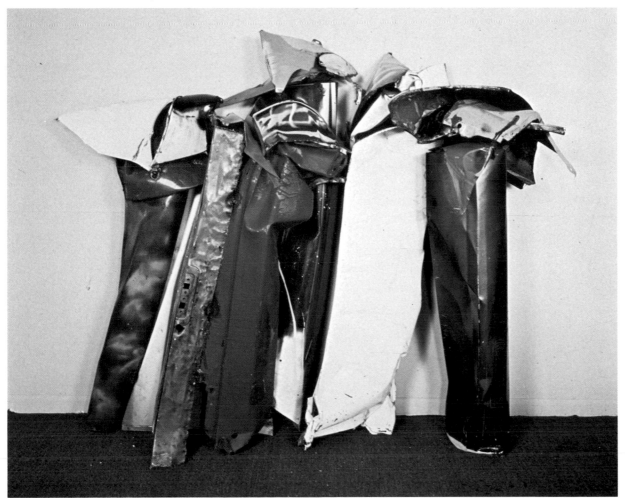

John Chamberlain
IDLE WORSHIP, 1980
Painted and chromium plated steel, 65½ × 8½ × 29 in.
Xavier Fourcade Gallery

63

ROBERT BARNES

Longtime Indiana University Professor Robert Barnes spends part of each year in Italy. Surrounded by the formidable classical and Renaissance models, and equally formidable epicurian pleasures provided by the Italian land and culture, Barnes still remains true to a basically literary sensibility. As the arcana of European secret societies and the optical allure of foreign landscapes comprise a large part of Barnes' subject matter, they are treated by him as if recorded by a writer, not an artist; they are described, not merely rendered.

That Barnes paints *events*, not just *scenes* is evidenced in the pictures he paints from actual novels, or more realistically, from and about the lives of the great writers. All Barnes' paintings have a theatrical air to them, but in their concupiscent complexity, their confluence of events bespeaking a whole narrative rather than a glimpse of one, his smaller pictures 'read' the way stories read in the mind, not the way they unfold on the stage. Finally, though, Barnes insists on his identity as a painter: not only does he revel in collapsing time into space, but he obviously relishes rendering this collapse with a supercharged brush and

64

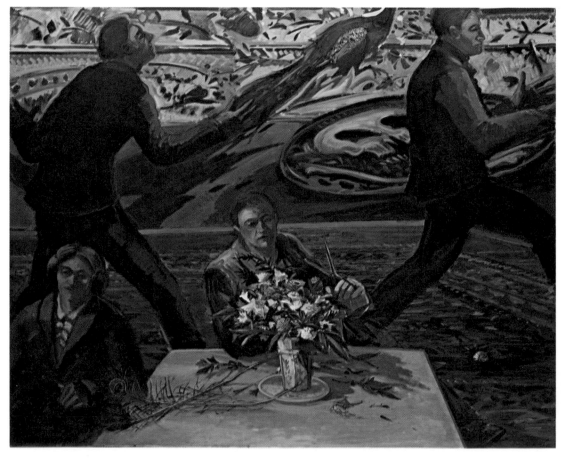

Robert Barnes
PARTING PEACOCK, 1979
Oil on canvas, 65 × 80 in.
Allan Frumkin Gallery

oddly-keyed palette. Barnes not only composes his images narratively, as is appropriate, but hyper-optically. That is, his colors and color combinations are raw, sour, disconcertingly high-key; he applies paint to canvas with a gusto approaching but not attaining abandon; and he orders his usually numerous elements as a massive interlocking of forms jostling in ambiguous, but never deep spaces, like Rube Goldberg machines in the process of overheating. The eye, once pulled into what seems at first an impenetrable tumult, cannot extricate itself, and does not want to. Like a good book, once you 'pick up' a Barnes picture, you cannot put it down.

65

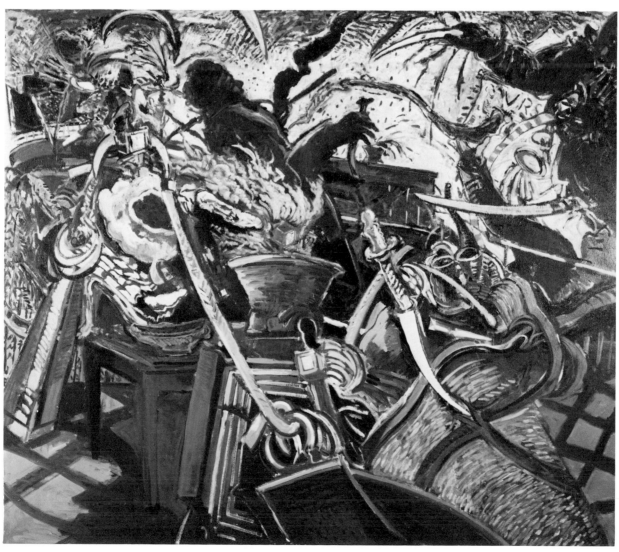

Robert Barnes
URSUS, 1982
Oil on canvas, 69 × 81 in.
Allan Frumkin Gallery

VIJA CELMINS

Like many painters and sculptors who came to prominence in the early 1970s, there is implicit in the way Vija Celmins reasons aesthetically a response to the two most prominent developments in art of the 1960s, Pop Art and Minimal Art. The focus on the object, on the thing or the scene perceived outside of oneself, rather than from introspection, carries over from Pop into Celmins' work. The particular focus she sustains—and the modular, quasi-mechanical aspect of repetition with which Celmins exercises this focus—bespeak Minimalism, as does the generally subdued, 'invisible' subject matter itself. Since 1968, this subject matter has been the textures of the surfaces of natural things and phenomena.

Latvia-born Celmins moved with her family to Indianapolis at the age of ten and studied at the John Herron School. Since her last para-Pop, proto-Photo Realist paintings and sculptures of the 1960s, which were done in Los Angeles where she still lives, Celmins has drawn bodies of water, the surfaces of rocks and pebbly ground, and astronomical formations as seen through telescopes. She is able to mimic

66

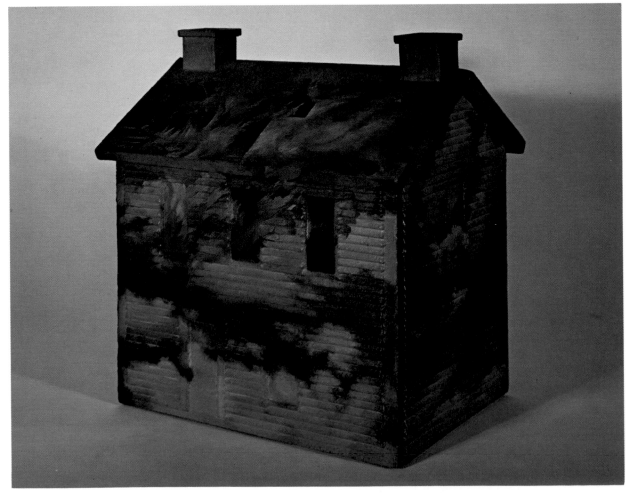

Vija Celmins
HOUSE #2, 1965
Oil on wood and cardboard, 12 × 9¾ × 7 in.
Private collection

the surface of actual rocks, and is able as well to mimic her *own* renditions of pits and waves and star clusters so that, without resorting to methods that refer to photographic technique, she exercises and capitalizes upon exact, and exacting, replication and re-replication. A replicated image becomes a unit, an element in a composition of two or three or seven such images. She is a virtuoso in the handling of drawings which present the same image in multiple rendition while others juxtapose different images. Obviously, the act of fabricating these drawings is an act of contemplation for all post-Minimalist realist artists. But unlike any other, Celmins concentrates on imagery that imparts that sense of contemplation to the viewer as well as to her. To dwell on these drawings is to enter the frame of mind Celmins enters to create them in the first place. This degree of viewer-artist empathy is unusual in current art.

67

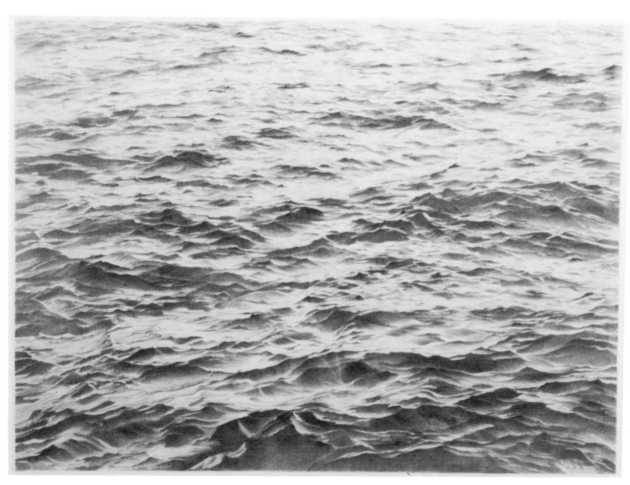

Vija Celmins
UNTITLED (BIG SEA #2), 1969
Graphite on acrylic ground on paper, 34 × 45 in.
The American Telephone and Telegraph Co.

JOHN CHAMBERLAIN

Stylistically and chronologically, Rochester native John Chamberlain is at the interstice between Abstract Expressionism and Pop Art, which fact has caused him to be thought of as something of a one-dimensional figure. He is fixed as the maker of junked-car-body sculptures. Actually, he also makes sculpture of similar formal power, order, and metaphoric potential out of aluminum foil, plexiglas, coated paper, and foam rubber. The significance of the automotive reference is reaffirmed by the proto-Minimalist paintings and reliefs Chamberlain has made in metallic enamel colors typical of car-body painting. Icon and material thus play similarly important roles in Chamberlain's thinking. But as his career has progressed, it seems that the nature of various materials has continued to engage Chamberlain, while the car associations are secondary. Given the kinds of associations that have accrued to the automobile in this culture, however, the other metaphorical presences in Chamberlain's work are not that far removed from his original engagement with the car. The suggestions of comfort and even sexuality in the foam rubber pieces recall the hedonistic associations with the car that are part of both the national myth and the crass address of commercial advertising. Speed and grace are evoked by the plexiglas pieces. The throwaway highway culture seems embodied in the crumpled paper pieces. Ultimately, though, Chamberlain's best works convey less prosaic ideas and impulses. The heroic, sometimes monumental, dignity of his work in his best-known material—painted and crushed steel—is enhanced, not necessarily by these associations, but by the more abstract dynamic of anguished, convoluted form which is obviously the violent manipulation of normally unpliable material. The interjection of a horizontal yellow element into a more or less vertical orange one, and a raw edge of their conjunction with its rust and solder, evoke the drama of a car crash only in the minds of those who dwell on the prosaic. In those more able to view things abstractly, the drama is in the sculpture itself.

68

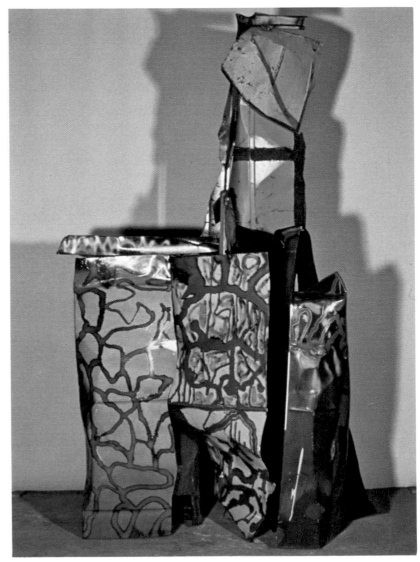

John Chamberlain
IMPURIENT WHEY, 1982
Painted and chromium plated steel, 109 × 74 × 51 in.
Xavier Fourcade Gallery

DO YOU THINK I SHOULD TELL
THESE STORIES OF IN DIANA
SO, TELL ME, WHAT WAS IT ABOUT IN DIANA
THAT MADE YOU CHOOSE IT TO BE BORN
ACTUALLY, I DONT THINK I HAD ANY SAY,
YES IT IS A GOOD PLACE TO BE FROM.

INTERESTING THINGS I CAN REMEMBER;
I ALWAYS HAD TOYS WITH WHEELS,
I WAS ALWAYS GOING AROUND THE BLOCK
THE BLOCK WAS THE WORLD
SMALL EXCURSIONS, WITHOUT CROSSING THE STREET,
SMALL WORLD, SMALL WHEELS

SMALL WHEELS GOT ME EIGHT STITCHES
IN THE HEAD, MOSTLY FOR BUGGING MY
COUSINDICKIE, HE HAD ONE OF THENICEST LITTLE
ELECTRIC TRAINS A KID COULD PLAY WITH.
NOT THIS LITTLE PARD, HE WAS SO CERTAIN NO ONE WOULD SCRATCH HIS
TOYS HE CLOBBERED ME WITH THE WRONG END OF A RAKE.

A FEW YEARS LATER HE PROVED CONSISTANT, THIS TIME
HIS BICYCLE WAS THE OBJECT, THE WHEELS GOT LARGER
THE ATTITUDE REMAINED THE SAME.
ABOUT THIS TIME I ADDED WINGS TO THE WHEELS
THE BLOCKS SEEMED TO GET SMALLER
THE HORIZONS GOT WIDER.

WHEN I WAS TEN I LEARND TO FLY AND IN SOME REMOTE
MEMORY ITS SEEMS I INVENTD RADAR, TWO DEVICES TO GET ME
ON THE ROAD
OBSESSION WITH TRANSPORTATION, TRY WALKING
A HIGH WIRE, MY FRIEND RICO GRETONA SAID
WE PRACTICED TOGETHER THAT YEAR, LATER IT HELPD MY DANCING

A TURN OF EVENTS IN 1832, CAUSED BY A
GRTGRANDFATHER SYLVESTER MARRIED
GRTGRANDMOTHER JOSEPHINE, OF ROME, IN NEW YORKCITY.
TRAVELED TO A CROSSROADS IN DIANA AND FOUNDED
CHAMBERLAINS SALOON & STAGECOACH STOP AT NINTH & MAIN,
THERE BEGAN SIX GENERATIONS OF SALOONKEEPERS, ENOUGH I THOUGHT.

IN THE BEGINING THERE WAS ONE BLOCK, LATER
I LEARND THE WORLD IS MEASURED BLOCKBY BLOCK
SO BE IT BIG WHEELS, WITH & WITHOUT WINGS, KAYAK, TRAINS, BUSES, CARS
I EXPANDED THOSE SOUGHTAFTER HORIZONS THAT, FINALLY,
GOT ME OUT OF
IN DIANA.

EXCUSE ME NOW,
I'M ON MY WAY TO GET MY DRIVERS LICENSE RENEWED.

–JOHN CHAMBERLAIN

GEORGE DEEM

Something of what is known as the 'post-modern' sensibility is embodied in the work of Vincennes-born George Deem. It is not a post-modernist concept merely to quote from the past, but to devote one's whole oeuvre to a constant reconsideration and reworking of images from art, literature, and history, is assuredly post-modernist. Deem has been quoting from famous artworks of the past for at least two decades, not copying other people's paintings, but making paintings *of* them. In these he re-examines and incorporates all the droll clichés misunderstandings, and personal reinterpretations that have accrued to well-known pictures since they became well known. When Deem re-renders Gilbert Stuart's *George Washington* — re-re-renders it re-re-re-renders it, every time shaping it differently, putting it in another spatial or narrative context or both, doing all sorts of witty and mysterious things to it—he is taking George Washington into account along with Gilbert Stuart.

A human icon of more current interest to Deem is the Russian vanguard poet Vladimir Mayakovsky, whose image he has taken from a Rodchenko photograph. Deem's abiding interest in Vermeer, however, is not so subject-oriented, unless the subject is not what Vermeer depicted but Vermeer's depictions overall. Time and time again Deem has introduced elements from one Vermeer painting into another, so that the famous *Portrait of the Artist in His Studio* takes place in the same room as *The Keyboard Lesson.* Deem is not above removing elements from a single image, so that we see only the canvas on which Vermeer was working in *Portrait of the Artist,* with no artist, and no model. Most irreverently, Deem also inserted elements from other people's art in his 'Vermeers', and vice versa. So when Deem places Mayakovsky in a bulldozer and sends him rumbling through the streets of Delft he is committing a revolutionary act by disrupting Vermeer's calm.

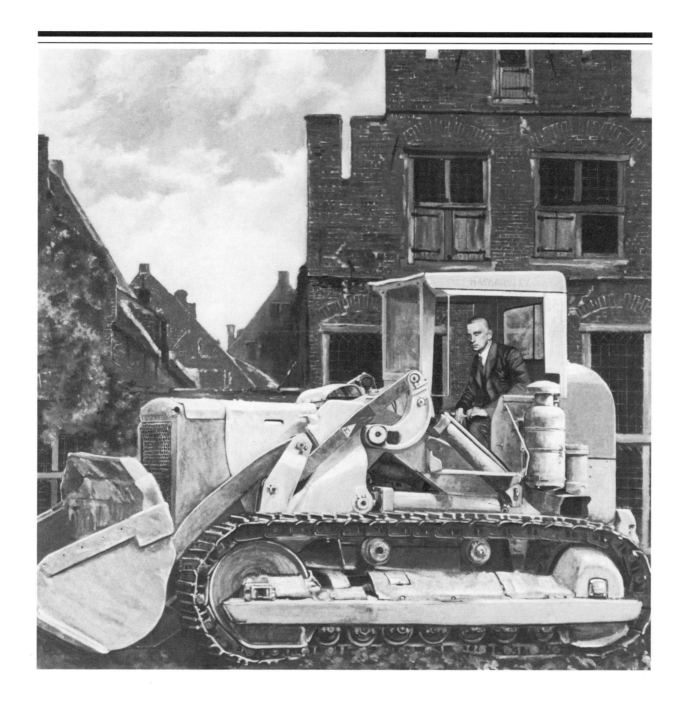

George Deem
MAYAKOVSKY IN A BULLDOZER IN
VERMEER'S SMALL
STREET IN DELFT, 1980
Oil on canvas, 50 × 50 in.
Collection of the artist

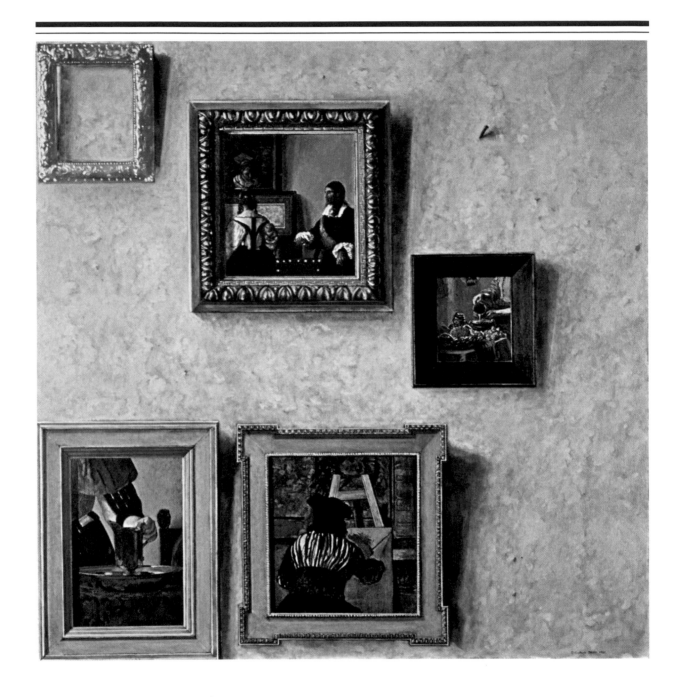

72

George Deem
FRAMES, 1982
Oil on canvas, 50 × 50 in.
Sid Deutsch Gallery

INDIANA AND GEORGE DEEM

"Dickie Williams's Peanut Poem:

A peanut sitting on a railroad track,
His heart was all aflutter,
Along came a train he did not see –
Toot! Toot! Peanut butter!"

"The farmer on the hill opposite the terrace walks his farm every Sunday morning. My father used to do that on Sundays on our farm in Indiana. I begin my day here walking the garden early every morning. It is important to look at your crop regularly, whatever the crop may be."

"When a squirrel is shot from a tree
and falls to the ground
it goes chickadeeskayloomdeeparlip."

"When I was a child I saw a film 'The Return of the Cat People.' It wasn't about cats at all. It was about a little girl who had an imaginary friend named Irene, but she pronounced it Eye-rainy. Later everybody at home told me how glad they were that I had seen the movie because they knew how much I love cats. I didn't know what to say because there were no cats in the film and I wondered whether my love for cats was true if I did not understand 'The Return of the Cat People.' I did like Irene being pronounced Eye-rainy."

"There was a man
who lived in a soda can,
he went to town and
bought himself a wife
on a merry-go-round
and then she died.
He went to the funeral
just for the ride.

–Joe Claus, 1940"

"There is nothing wrong with an
unpicked flower."[1]

"Through sick and through sin,
people remember what
they remember.

There is not time when
there is no plane in the sky.

Winter sky comes into mind
and moments when one can see the sea
and watching red become rose.

The sun was sinking in the sky,
And me and Dad went out to milk,
Shreds of color everywhere,
We were all under a quilt.

Green turning into red,
A knife standing in wood on its point,
A photograph of boiled potatoes.

But you have flowers in Florida,
It's in the eyes of the ambulance driver.
Music box jewelry.

You are different when you use
the blue toothbrush.
I'm almost,
almost the same exactly."[2]

73

[1] Excerpts from "Extra Genre," notes from an Italian diary by George Deem, published in White Walls; A Magazine of Writings by Artists, #6, Chicago, Summer 1981
[2] Excerpt from "Actual Size" by George Deem, published in Benzene #8, New York, Fall/Winter 1983/84.

WILLIAM DOLE

There is a tradition in modern art of collage for collage's sake. It is a tradition normally subsumed into other formats and attitudes. But on occasion this tradition gives itself form, usually in the oeuvre of a single individual rather than in a movement or zeitgeist. In the Cubism of Picasso and Braque, for example, the collage aesthetic was germane but not predominating; in Kurt Schwitters' case, however, that aesthetic was paramount.

It was paramount in the art of William Dole, too, after about 1958. At that time Dole, a quiet and erudite native of Angola who died in 1982, refined his increasingly simplified, architecturally-oriented realism into an abstraction in which Constructivist values were elucidated. But Dole was not interested in a Constructivist

purity. Indeed, he seemed vaguely repelled by it. In his collages, Dole seemed to find a way to hold the exterior world within his refined compositions. They show a distilled world, ordered, selective and often homogeneous in the identity and texture of its imagery, but they are rich in erudite reference and the engagement of traditional arts and disciplines. Old print abounds, as do snippets from other printed material out of antiquarian sources. This gives Dole's collages a hybrid air, somewhere between an illuminated manuscript, a princely document, and an Oriental scroll-text. Many of his collages can actually be *read*,

74

William Dole
CRITERIA, 1979
16½ × 24½ in.
Staempfli Gallery

although they yield not discourse, but only clues to discourse: multilingual, multicultural snippets whose abrupt or distant conjunctions make Ezra Pound's cantos seem garrulous and prosaic. Nearly every Dole collage is comprised primarily of pasted papers bearing no extraneous information; rather, the papers bear tint or only the texture of their own material. The presence of type and writing suggests textuality, but this is not the main reason for calling Dole's collages poems. Rather, they are the visual-art equivalents of poems, spare in their visual diction, emphasizing rhythm and resonance, memory and metaphor. They are discreet but powerful in their oblique conjuration of the world.

William Dole
DIA PASON, 1979
Collage, 10¼ × 12¼ in.
Staempfli Gallery

JOHN DUFF

To characterize John Duff's art as a perfect paradigm for post-Minimalist sculpture is not to deny his persuasiveness as a distinctive talent. In fact, it is his idiosyncracy, his individual and seldom predictable response to materials and forms, that helps assign his paradigmatic status. Duff, born and raised in Lafayette, is not a formula sculptor; one can generalize about his style only in terms of its relationship to its predecessor, Minimal Art. Duff seems to begin with forms and formal problems dictated by Minimalism and its lessons, only to undermine these lessons with unanticipated responses—to answer the formal problems by posing other formal problems on top of possible but tentative solutions to the Minimalist questions. The eccentricity of even his most reductive pieces results from a seemingly reticent but always steady employment of coarse and coarsely-finished materials such as fiberglas, iron and industrial paints in the fabrication of odd and unsettling shapes. These shapes are baroque or jocular deflections of the Minimalist formal vocabulary, too delicate and dignified to be read as overt burlesque, but rather as sly and gentle mockery. They depend on irregularity, on inverted symmetries, on scale and position that neither puts the sculpture *in* the way, like most Minimalist work, nor *out* of the way, like much post-Minimalist small-scale work. Every Duff piece seems to have a personality, scaled and shaped to distinguish itself from every other Duff sculpture—and from everything else in the world as well. Duff's liberal emphasis on surface quality is part of this emphatic characterization; indeed, it might

John Duff
SEA KITE, 1983
Fiberglas, 60 x 12 x 17 in.
Collection of the artist

not be possible without it. But the characterization is based on Duff's willingness to engage a wide formal vocabulary—even though it is basically limited to angled shapes—and especially to conjoin the elements of this vocabulary into demonstrations of continually unpredictable visual syntax.

For the first eight years of my life and nearly every other year for the next eight my mother packed first me, later my sister and brother, too, into the car for the trip from Los Angeles back to Attica, Indiana, always arriving in time for the

extended family 4th of July picnic at Uncle Wayne's cabin by the lake. My mother always made the trip in five days even when she wanted to take longer and, although it was five days of hard driving because of my mother's love of antiques, it seemed like we were always stopping at shops along the way. Now freeways don't allow for those kinds of excursion, for the sake of efficiency you're sped on your way without much of anyplace to stop and without really much of anything to see. That beautiful trip has, I'm afraid, become rather bleak. But this was in the forties and early fifties, and along Rt. 66 from Oklahoma to Indiana (in the desert were the curio shops—but that's another story) there was a large number of antique stores, and we stopped, and we looked, bargained and bought. To me, as a child, these were wonderful places and they made a strong and lasting impression on me. The name of one such place, "Trash and Treasure," comes to mind, a cliché to be sure but still there is a real meaning there, an aesthetics of refuse, a challenge to the idea of refuse that somehow fitted in with other aspects of my childhood experience becoming a factor in my developing sensibility. The objects we call antiques embody the values of an earlier America (the British art historian Herbert Read said something to the effect of—to gauge the aesthetic vitality of a culture, look at its ceramics). My sense of what those values are, my measure of the distance between "trash and treasure" is much of what my life is about now, and the work I do.

—JOHN DUFF

MARY BETH EDELSON

East Chicago native Mary Beth Edelson's career, in the last decade, has not just followed but has embodied the rise, acceptance, and assimilation of feminism in art. Edelson, who took her B.A. at DePauw University, originally became known for her ritualistic performances and installation pieces which were highly ordered and symmetrical affairs based on aboriginal ceremonies. In fact, the pieces had their models in the quasi-religious demonstrations of pre-civilization, but are invocations of contemporary concerns, formulated to tie the distant past together with the present. By distant past is meant the pre-historic period of presumed matriarchal dominance. Edelson's rituals were designed to demonstrate and renew feminine power among today's women. Although the goals of contemporary feminism are far from completely achieved, there has been enough advancement, and enough indication that this advancement is not temporary, to allow committed feminist artists like Edelson to address broader or more purely personal concerns, or both. In her more recent work Edelson does so, although she continues to address herself to the idea of mythology and to the imagery and narrative discourse pertinent to it. An entertaining series of pictures depicts "Trickster Rabbit," the animal embodiment of human mischief and guile, especially on the part of the male, in his exploits.

More sober, but still tinged with a certain wit, are the new paintings—the largest paintings that Edelson has done. These voluptuous, swirling images center around ancient sculptural figures such as the Winged Victory of Samothrace and a pre-classical head of Persephone. These cast the central images, not in narratives pertinent to their legends, but in abstract, iconizing ambiences of jagged rocks, swirling maelstroms, threatening volcanos, and agitated clouds, focused in their brute energy on the serene sculptural presences in their center. Most of these paintings have objects, such as large bolts of fabric, or simple utilitarian objects, or devices echoing the icons themselves, appended to them; but these objects are designed to be removable and, to a large extent, even interchangeable. The objects serve to enhance the votive nature that continues in Edelson's work, while the treatment of the images themselves displays her belief in the appropriateness of current personal mythologizing and reconsideration of historical art models.

78

I've been out east for some time now, but people still ask me where I am FROM. I guess that question comes because of my direct, straight-on approach.

My mother came from a farm in southern Indiana, but when she met my dentist father she was living in East Chicago—where we three kids grew up. "Da Region" as it was called then – and worse. But, I'm glad I grew up there, the rich ethnic mixture of people newly arrived from almost every point of the globe, was an instruction in how to get along with people very different from yourself. In fact, I was 19 before realizing that W.A.S.P.s like me, were not a minority group in the U.S.A. East Chicago (the Harbor side), was not much like the rest of the state, it was Indiana's Westside Story—a prideful and courageous place that shaped attitudes that influenced the work that I do today.

When I returned to Indiana, (Indianapolis), in the early 60s after living in NYC in the late 50s, I couldn't get a job teaching art on a college level, as I had done in NYC—they simply did not hire women, nor were they showing our work if they could get around it. I started several projects myself trying to get around these handicaps. Indianapolis in those days seemed surreal to me—my perceptions were at odds with those around me. I tried to fit in, painting what I saw—a flat world where women were expected to create cheerful environments and make do. When I left Indianapolis for Washington, D.C. in 1968 I wanted to sort out what had happened there and my work became surreal. I have been living in NYC since 1975. I come back to Indiana to see my family, and also to give an occasional lecture on the college circuit as well as to exhibit my work.

–MARY BETH EDELSON

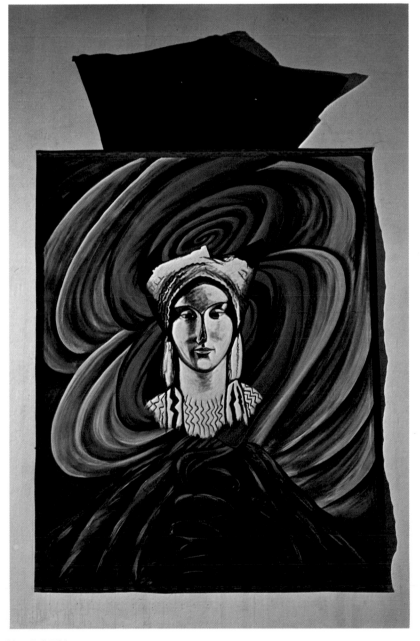

Mary Beth Edelson
SPIRALS OF PERSEPHONE, 1982
Acrylic on canvas, 132 × 72 in.
Collection of the artist

79

ART GREEN

Art Green, born in Frankfort and now a Canadian citizen, has long been associated with the group of Imagist painters who came to prominence in Chicago late in the 1960s. He shares their preference for highly stylized, almost cartoon-like figuration, sharp contour, high-keyed color, and intricate detail. Despite this, a clarity and almost hieratic rectitude pertains even in the densest, craziest Green painting. This rectitude stresses formal coherence and provides a tension between compositional exactness and iconographic quirkiness. The same might be said of Green's Imagist compeers Ray Yoshida and Roger Brown, but in their cases they achieve visual clarity through elemental linearity and emphatically simple organizations of forms that evoke a child's sketch or a dictionary diagram. While this 'dumb' approach is appropriate to Imagists' love of crude pictorial sources, Green eschews it for the opposite extreme. His is an imposingly complex field of visual activity ordered by exaggerated symmetricality, ornate decorative gestures—the most apparent being his frequent willingness to shape his canvases in whatever way the tumble of images and objects dictates—and by skewed and conflicting recessional renderings. This massive confluence of egregious optical dissonance and perverse harmony couples with an exaggeratedly slick technique that would certainly be the envy of the urban folk artists (e.g., hot rod painters, graffiti writers) whom the Chicago Imagists have themselves long emulated.

Artists in New York, Los Angeles and other American cities have also emulated such non-art models, but the Imagist's celebration of the art of the unsophisticated has extended

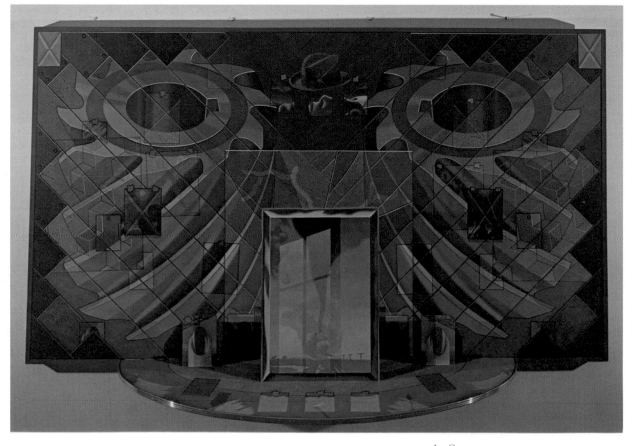

Art Green
CRITICAL MASS, 1982
Oil on canvas on wood, 55½ × 97¼ × 24 in.
Phyllis Kind Gallery

80

beyond this purview to focus on the folk carvers and the simple drawers, mostly black or native American, working today in the cities and outside. Green's work owes less to these gifted innocents than does that of most of his fellow Imagists, but their love of busy, intricate compositions and their tendency to subsume narrative—as obvious as it may be—into the compositional intricacies are characteristic of Green's glossy, convoluted, often oddly- but never awkwardly-shaped pictures.

I was born in 1941 in Frankfort, Indiana; where my father was a civil engineer with The Nickel Plate Rail-Road. After moving to an Ohio railroad town, we returned to Indiana, settling in Fort Wayne in 1953, where I remained until leaving for art school in Chicago in 1960. As I was born and lived through young adulthood in Indiana, its influence on me has been profound. I have intense memories of Indiana in the 1950s: the countryside and small towns south of Fort Wayne; the vast reaches of Gary and Whiting at night, seen from a train window; the excellent Fort Wayne Public Library; Saturday classes at the Art Museum; Indiana apple cider; thousands of things. My life has been shaped by growing up at that time and place. It has also been shaped by people; by my family and relatives, still living in the area; and by friends and teachers. As an example, I owe a great deal to my high school art teacher at South Side, Mr. Leon Smith, whose classes stimulated and developed my interest in art, and who subsequently harassed me into applying for admission to the School of the Art Institute of Chicago.

In short, I lived some crucial years here, and I am pleased and honored to be included in this exhibition.

—ART GREEN

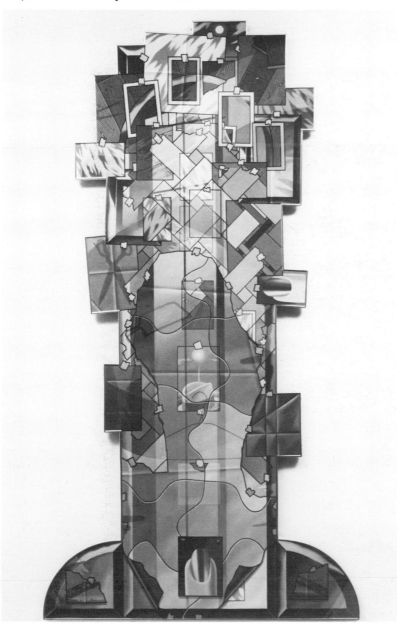

Art Green
RISKY BUSINESS, 1980
Oil on canvas, 77 × 41 in.
Phyllis Kind Gallery

81

DAVI DET HOMPSON

Davi Det Hompson
LOOKS ARE WHAT I KNOW, 1984
Acrylic on paper, 84 x 60 in., each of four parts
The artist created a site specific installation as a
spontaneous event for the exhibition.

Ever since his University of Indiana days in the mid-1960s — following his stint with the Navy in Anderson, where he matriculated from Anderson College—Davi Det Hompson (whose name is indication enough of a playful verbal nature) has concentrated on the engagement of word and situation in his artwork. In fact, word and situation *is* his artwork. Imagery is not necessarily absent, but is always subordinate to the presence and message of narrative snippets and to their installation in and about a space. The installation is not decorative gesture or grandstanding ploy; by arranging or 'throwing' his wordworks all over the walls of the space in question, Hompson activates the space dramatically, although not quite theatrically. This strategy is an expansion on Hompson's best known format, that of simply printed and presented 'artists' books,' in which overarching narratives and states of mind are implied with single sentences and phrases. The brevity of these lines, and the tenuous but immediately sensed connection between them, makes each book almost a Rorschach blot for each reader to respond to with his or her own interpretations.

The installations are less broadly and deliberately elusive, but attitudes and events are still left ambiguous by the words and situations. Viewer interpretation is still central to the conception of the wall pieces; the humor and poetry of the words, and the visual charge they are given in their site-specific installation, are as oblique as they are for their Haiku-like simplicity. Hompson obviously concurs with Marcel Duchamp's dictum that, in essence, the viewer completes the work of art. Considering Hompson's association during his Bloomington years with the post-Duchampian Fluxus movement, with its love of gags, intimate and almost invisible gestures, and pervasive desire to engage its audience actively, he has developed what is actually an international sensibility into a distinctive and expressive personal vehicle, without disengaging his audience at all.

Indiana, where car-hours measure the distances to someplace else in all directions. I lived in the eye of a lifestorm, secure and unmoved, warned by flat-road voices of cities with only three dry sides where people would place intentions above deeds and results above method. I learned to consider more than a handshake too intimate, an accent suspicious and labor accomplished by words alone trivial. We who walked across the horizon to the world's whirling edges did not expect to carry our land's calmed center with us.

–DAVI DET HOMPSON

BRYAN HUNT

Terre Haute-born Bryan Hunt has participated for at least a decade in the odd-scale mentality of post-Minimalist American sculpture, making small distorted dirigibles out of balsa wood, silk and paper and, more recently, making waterfalls out of bronze. Waterfalls? Out of bronze? How does one make a sculpture out of a waterfall? From a one-line description one would imagine a paperweight-type casting of rocks with a couple of trees and a molded cascade of water, its flow frozen eternally in bronze, all very detailed and veristic. But Hunt isolates the waterfall itself from everything else, so that the sculptural form embodies only the arc and chute of the water removing it—or abstracting it if you will—from its natural surrounding.

In the last few years Hunt has taken this formal sensibility and advanced it by abandoning the very context from which it emerged; the bronzes he makes now no longer derive from a specific class of real thing in the world, but build abstractly on the highly textured, cresting linear forms characteristic of waterfalls. These forms may now work themselves into large free-standing presences with long, spindly legs, vaguely architectural arrangements of bent and crossed struts and slabs, and formal free associations on other objects such as chairs or vessels. These associations are often evoked through the description of contour rather than actual volume. On occasion, Hunt will incorporate material other than bronze, but up until now the ancient semiprecious metal has been his mainstay, his way of posing the idea of permanence, both physical and aesthetic, in opposition to the idea of transition, which is obviously embodied in the flux of the waterfall. The droll irony of this internal counterposition gives these sculptures, which are formally exquisite in their own right, their added allure.

REMEMBERED GATE

INDIANA WHERE IT WAS
 THE BANKS OF THE WABASH
 SYCAMORES LEANING TO
 SPAN THE RIVER.
 RIVER MOVES SLOWLY SOUTH
 FIELDS, FARMS, REPETITION
WITH VARIATION
 INTO THE QUARRIED LIMESTONE
 WALLS–
 SOMEHOW KNOWN AS THE
 PLACE YOU GO THROUGH
 TO GET SOMEWHERE
ELSE.
 WHICH WAY IS THROUGH?

 SEEMS CYCLIC AND ALWAYS,
 –A DESTINY.
 FORETOLD WITH THE
HARVEST MOON
 AND DEEP SLEEP OF WINTER,
HOPING TO SPRING
 FORWARD
 LIKE A WARM AFTERNOON NAP
 ON GOOD OLE EARTH.

– BRYAN HUNT

84

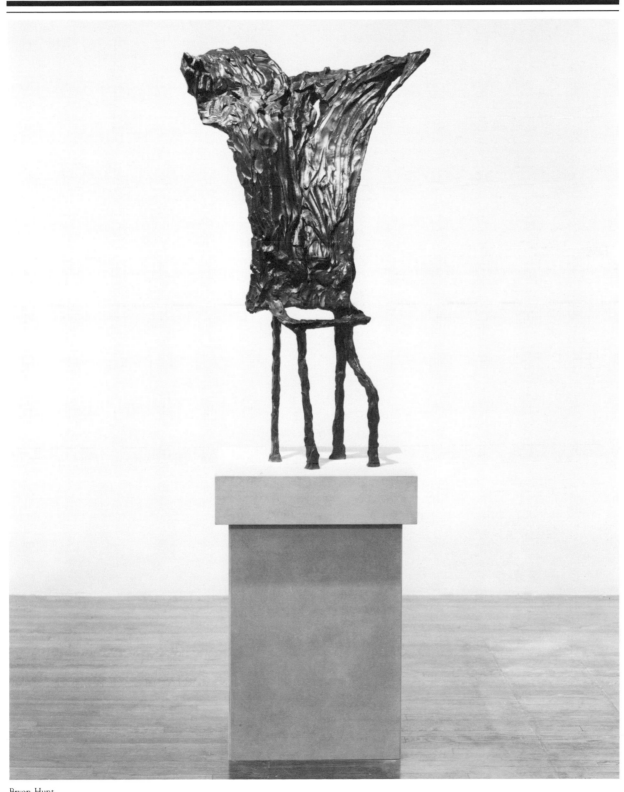

Bryan Hunt
LAFAYETTE CHAIR, 1981
Cast bronze, limestone base, 52 × 31 × 14 in.
Blum Helman Gallery

JIM HUNTINGTON

The juxtaposition of disparate forms and materials, and the intricate ways in which this juxtaposition is effected, has long characterized Jim Huntington's sculptural work. Whether they are tall and erect or squat and self-enclosed, whether free-standing or placed on a pedestal, Elkhart-born and Bloomington-educated Huntington argues in his sculptures for the conjunction of smooth and rough surfaces, light and heavy hefts, reflectivity and coarse opacity, natural color and the dull glint of industrial metal. The surfaces of his works would seem to state a preoccupation with sensuosity, and Huntington's sensitivity to the qualities of disparate substances in superimposition is markedly tactile. But there is a less purely haphazard aspect to Huntington's thinking, too, an aspect which doubles Huntington's sculptural role, adding that of constructor to that of molder-carver.

While Huntington delights in simple forms, in forms which in and of themselves have an accidental look—as with irregular marble and limestone chunks—or a self-effacing plainness—as with panels of rolled steel—he recognizes that their natural attraction can be enhanced with a little formal intellectualizing. The manner of conjunction in Huntington's pieces is invariably a surprise when the rawness and simplicity of the elements are considered: involved interlockings, skewed angles of intersection, forms and substances all pierce others obliquely, almost invisibly. These odd articulations are never the factors that catch the viewer's eye first, but they are always the things that hold the eye—and the hand—on the piece, searching for a clear understanding of the playfully odd forms and discovering odder and odder aspects until an almost architectural intricacy is comprehended. Only then can the viewer step back again to appreciate the sensuous qualities, encouraged at last to think of them in a more complex light.

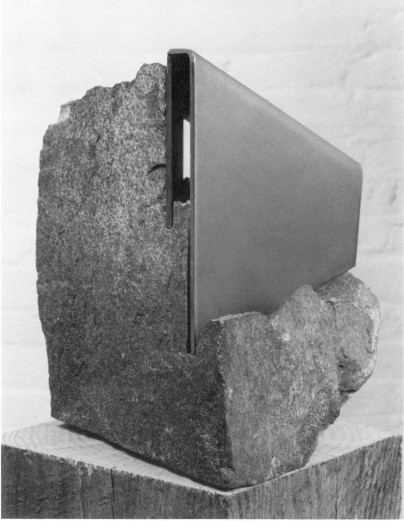

Jim Huntington
CHOPPER, 1981
Granite and stainless steel, wood base, 12½ × 13½ × 10 in.
Collection of the artist

When, as a sculptor in my late twenties, I started to read David Smith, I was astounded at the similarity in our attitudes about so many basic things. David Smith is a spiritual father for me and I am drawn to conclude that what links us so specifically is our shared background and formative place: Indiana.

All my life I've wondered why I am an artist and what growing up in Indiana had to do with it. From the time I was about four years old (I started school that year) I knew I was going to be an artist. My parents tell me that the only thing that would hold my attention and keep me quiet for hours was drawing; so naturally, I was provided crayons and paper whenever my parents wanted a break from my noisy, frenetic behavior, and I was encouraged to scribble away for hours.

I believe that, as the result of some genetic mystery, certain of us have an inherent predilection for a specific activity in life. It has always seemed inevitable to me that I be an artist. Place and environment have an ineffable but profound effect on all our lives and Indiana gave me a complex treasury of sensual memories and reveries: of seasons, of light . . . a myriad of kinesthetic experiences, layer upon layer, had their indelible effect.

At the time I was born, my father was a blue collar worker in a factory and over the years worked his way up to a white collar job. By both example and instruction he taught me respect for the simple, basic values of our midwestern community—hard work, integrity and dignity. He gave me a sense of my own worth and the courage to act. I believe that inspiration, diligence and perseverence will ultimately get me what I want.

In my earliest consciousness, I remember having a sense of infinite possibility . . . to dream, to become, and though I've always been a dreamer, the pragmatism of the puritan work ethic has been my tether to the earth. Over the years, I've grown to deeply appreciate and understand the values that were imbued in me at an early age and to feel them as a source of sustaining strength in pursuing my vision as an artist.

–JIM HUNTINGTON

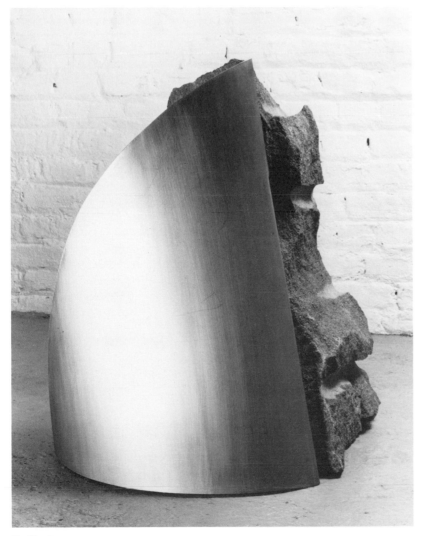

Jim Huntington
ARC ANGEL, 1982
Granite and stainless steel, 28 × 26 × 14 in.
Collection of the artist

87

ROBERT INDIANA

Perhaps the first Pop thing Robert Indiana ever did was to change his last name, from Clark to the state of his birth. Like his contribution to Pop Art, however, this seemingly simple, almost heraldic gesture by the New Castle native had a deeper, more private meaning, indicative of autobiographical detail more complex than it would seem at first. Every Robert Indiana image, whether given form as painting, sculpture, construction, print, banner, or postage stamp, carries iconographical as well as gestural weight. Indiana has, in fact, been responsible for redirecting America's attention to its own signs, to its brief linguistic indicators in their pre-semiotic state. The ciphers flashing by on billboards, roadside stands, and freight cars do not communicate information so much as trigger verbal association. In Indiana's work, memories of the highway are triggered and nostalgic recollections are provoked of signage we have so fleetingly apprehended in our own pasts.

But Indiana does not just seek to draw our attention back to this aspect of the new American landscape: he employs this means to limn his own history. The famous LOVE pieces, the numbers, and other monosyllabic images are basically universal resonances, but his other pictures

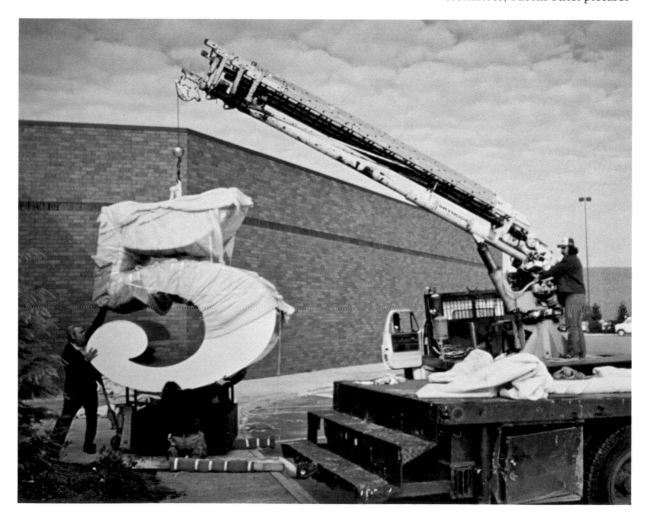

and objects can be unraveled according to their associative significance with incidents and impressions from his own life. The artist's early life, in and around Indiana, is of course dealt with throughout his oeuvre, but his mature and professional life has also provided material for his work, as have his enthusiasms for certain artistic predecessors. While willing to discuss these below-the-surface meanings, even to unravel his whole self-documenting iconography, Indiana has never insisted on it; the role his work has long played in Pop's aestheticization of the contemporary American landscape—a process which comprised of equal parts irony and sentiment—has been in its own way a satisfaction of his broader goals. These goals of nostalgia, patriotism, the visual, and the poetic, are easily shared with others and provide the substance for further, more intimate communication.

Robert Indiana
5, 1982
Acrylic on aluminum, steel base, 96 × 96 × 48 in.
Melvin Simon and Assoc., Inc.

WILL INSLEY

If one looks at the history of architecture, which is supposedly a discipline of thorough-going practicality, one finds a good deal of visionary invention. Indeed, there is a whole tradition of audaciously projected 'impossible' architecture. It is in this, rather than in any more mundane tradition, that Will Insley's work seems to fit. Insley, a native of Indianapolis, can be aligned with Minimal Art, given his long-time reliance on the grid and the incorporation of the grid as the basic image in his paintings which are often shaped canvases. But for Insley these have been steps toward, or parts of, a whole that is a quasi-utopian approach to architectural spaces. For most of the last decade he has oriented his work toward the rendition of architectural projects, most notably "Onecity," an entirely manmade environment which incorporates all social and natural functions. Those works which have not fed into and developed the Onecity concept *per se* have still demonstrated Insley's basically architectural vision. In the artist's words his works

90

Will Insley
VOLUME SPACE INTERIOR SWING,
ISOMETRIC X-RAY VIEW
THROUGH THE GROUND, 1973/80-81
Ink on ragboard, 40 × 60 in.
Max Protetch Gallery

identify his "interest in the poetic-mythological-entropic possibilities germane to architectural and/or engineering vocabulary"—that is, architectural thinking as an end in itself as well as a source for spatial and functional definition.

It should be noted that the approbation "quasi-utopian" for Onecity gives an indication as to the nature of Insley's vision. He is not setting out in his work to reformulate, and thus to improve, the world. He does not expect or even hope to see Onecity built. Rather, he believes that Onecity already exists. Like his other work, it is a manifestation of his imagination, and exists sufficiently in the telling and the drawing.

I was born in Indianapolis and lived there through my high school years. One major influence of an Indiana boyhood on my later work as an artist was the flat open landscape. This familiar country space became the natural context of my future architectural information. The pair of house and barn inserted into the horizon, the small clump of trees isolated in a field, the importance of a single hill silhouetted against the sky were common sights along the straight and level roads of our many trips through the Indiana countryside. Best of all, I liked the corn fields and their regulated sea of light rippling over a shadowed mysterious space hidden beneath. I always think of my abstract buildings as situated in the centers of those fields. The drawings in this exhibition relate to two such buildings which do not rise above the ground at all. Buried in the center of a field, they are invisible to the outside world.

—WILL INSLEY

Will Insley
VOLUME SPACE INTERIOR SWING,
SECTION THROUGH CENTER, 1973/80-81
Ink on ragboard, 40 × 60 in.
Max Protetch Gallery

TERENCE LaNOUE

If one can pin any label on the rich but elusive painting of Hammond-born Terence LaNoue, it could only be something like "adductive abstraction." Such a term, although like most such labels it is misleading in its incompleteness, would indicate the formal and even iconographic thinking that informs LaNoue's aesthetic. It is not so much that 'anything goes' in his painting, but that anything that can fit should be tried. LaNoue's compositions are not just busy, they teem with detail. His surfaces are not just thickly impastoed, they are grooved,

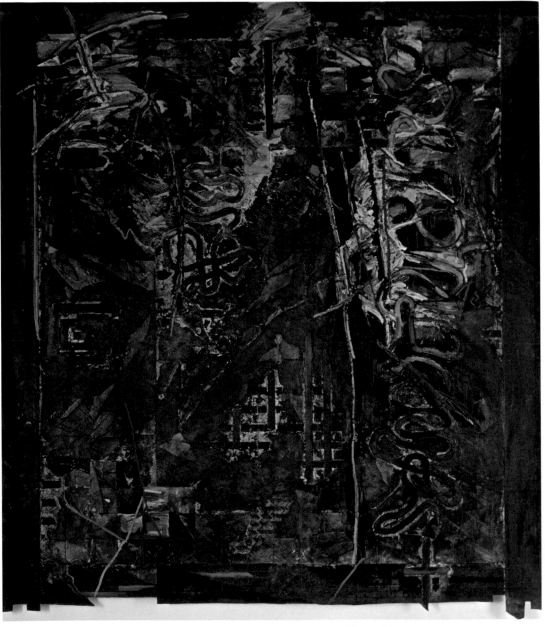

Terence LaNoue
WINTERKILL: MOONLIGHT, 1981-83
Acrylic paint, graphite, metallic powders and other materials on canvas, 95⅜ × 83¹¹/₁₆ in.
Siegel Contemporary Art, Inc.

roiled, and slathered into frenzies. His free-hanging canvases are not just square, they are modified around their perimeters in irregular ways which extend the formal activity on the canvas. LaNoue's colors are brilliant and oleaginous, incandescent and never quite definite. His paintings are literal presences, they are sculptural, much the way wall-hung fiber art is sculptural; plus they contain much deft and splendid manipulation of pigment.

In composing his pictures and choosing his forms LaNoue is similarly voracious. No linear or textural figure takes on the identity of prosaic things or their symbols. But the recurrence of squared spirals, irregularly hatched checkerboards, looping intestine-like trails, and other devices that have become increasingly common in

LaNoue's large paintings is suggestive of native American petroglyphs or the pre-scriptural markings of aboriginal cultures. Although these works are only made of various kinds of paint on canvas they take on an 'objecthood' expanded well beyond our traditional concept of painting.

I was born and grew up in and around Hammond, so many of my first important experiences took place in Indiana.

One of my grandfathers owned a hardware and feed store in Remington, and I often worked for him in the summer. The store was huge, not unlike the lofts that one encounters in SoHo, the vast displays of merchandise and seed—my first museum. My other grandfather was a carpenter—a man who inspired one to believe that there was nothing that couldn't be done with one's hands.

My first plane ride was at the Lake County Fair in a two-seater open cockpit plane. I have looked out the windows of many places since then—over the deserts of Mauritania, the Deccan of India; and the Annapurna Range of Nepal—but nothing was more thrilling than to see that flat Indiana land take on a wonderful configuration of pattern, line and form on that day in Crown Point, Indiana.

– TERENCE LaNOUE

93

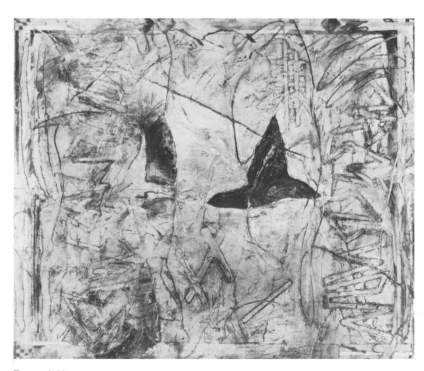

Terence LaNoue
KUALA LUMPUR, 1981-83
Acrylic paint, metallic powders and other materials
on canvas, 92 × 106³/₁₆ in.
Siegel Contemporary Art, Inc.

JAMES McGARRELL

The Surrealist spirit darts through the work of James McGarrell, although it is freed almost entirely of the associations and mannerisms of the Surrealist movement. McGarrell's odd, discomfiting, highly but ambiguously charged interactions between figures, taking place in vertiginous spaces simultaneously as close as your hand and as far away as the horizon, partake of the spirit of dislocation that inflects most of quotidian life in the twentieth century. Max Beckmann was especially sensitive to this pervasive sensibility and for McGarrell, Beckmann was one of the truly concise embodiments of this transfixing but never transfixed world view. It is fitting that,

when McGarrell left his Indianapolis birthplace and his longtime association with the University, it was to go to St. Louis and Washington University, the school and town that became Beckmann's home when he left Germany. McGarrell's uneasy para-realism no longer shares Beckmann's expressionist inflection, although it did in the early 1960s. Since then, an Italian orientation, from spending summers in Umbria, has given his touch and composition a more classical tone. The Roman

idea of the frieze, especially as modified by Renaissance masters, is ever-present, even in non-horizontal compositions; it argues constantly with another tradition of Renaissance-Baroque classicism, the distant landscape. By superimposing the two conventions, McGarrell effects an unconventional ambience. Such a conjunction could be seen as an ironic affectation of modernist or post-modernist historicism, but in McGarrell's hands it is much more meaningful than that, on a level purely of personal expression and viewer response. The people and places McGarrell paints are not compelling for their conjunction nor for their narration, but entirely for their air of mystery, enhanced by a pervasive sense of *déjà vu*. Of the many elements comprising a McGarrell picture, every one of us has experienced—or more likely dreamed of—more than one.

94

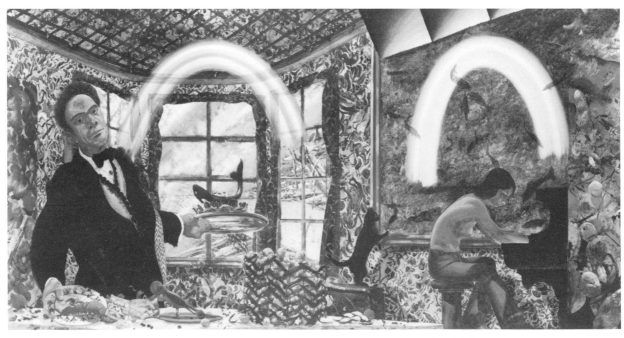

James McGarrell
THE GRAND MEDITERRANEAN, 1983
Oil on linen, 41 x 80 in.
Allan Frumkin Gallery

I was born in Indianapolis and attended elementary and high school there before matriculating in 1948 to Indiana University in a pre-law curriculum. When I had to drop out of school to earn money in factory jobs in Indianapolis, I started to paint and draw. I had been very interested in early New Orleans jazz and after I had read all the books the Indianapolis Public Library had on the subject I moved to the next shelves which contained the art section. Reading picture books about Cezanne, Gauguin and Matisse got me started. I returned to Bloomington but didn't become an art student until my Junior year. A few great teachers, Leo Steppat, Alton Pickens and George Rickey nurtured and spoiled me. Years later when I returned there to teach they had all left.

In the meantime I had studied on the West Coast, in Maine, and in Europe. I had started to exhibit fairly widely, had some paintings reproduced in a few art magazines and had been teaching for 3 years at Reed College in Portland, Oregon when Henry Hope, recognizing that there was no longer any question of in-breeding, invited me back to Bloomington to head the graduate painting program. With frequent and sometimes prolonged absences to live and work in France and Italy, Indiana was my permanent station from 1959 to 1981.

How can a painter measure the importance for his work of a place where he has been visually nourished for much more than half of his life? I am not one of those figurative painters who works from direct visual sources such as still life setups, posed models or photographs. I draw upon indirect, internal sources – chiefly memory, vocabulary, deep seated kinetic impulse, and conceptual invention. So, no matter where in the world I may be painting, much more than half of this information will probably be Hoosier.

–JAMES McGARRELL

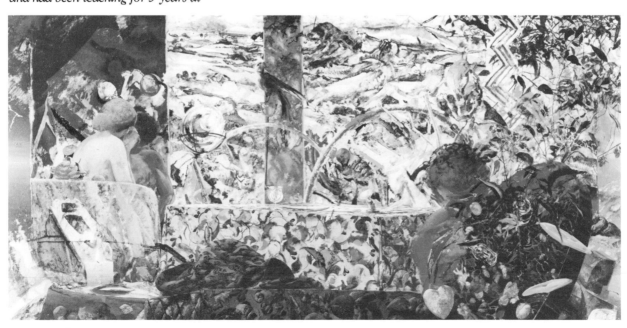

James McGarrell
SECRET STILL LIFE, 1981
Oil on canvas, 45 x 93 in.
Allan Frumkin Gallery

RONALD MARKMAN

Ronald Markman is now completing his second decade as a teacher at the University of Indiana. He is one of those artists who, not content to create a style, look, or attitude for themselves, create their own countries, worlds and cosmologies. Markman's personal paradise is a highly—some might say overly—civilized island state or republic or kingdom called Mukfa. The capital city Markman's art inhabits and depicts is Poc Poc. As Markman describes it visually, Poc Poc is a nice place to visit and a daffy place to live. Ordinary life there is rife with hilarity. Indeed, it is a cartoon country, a land and city of comic-strip improbabilities rendered by Markman in comic-strip style. Nutty things happen to people; odd encounters take place in landscapes teeming with non sequiturs; still lifes refuse to sit still.

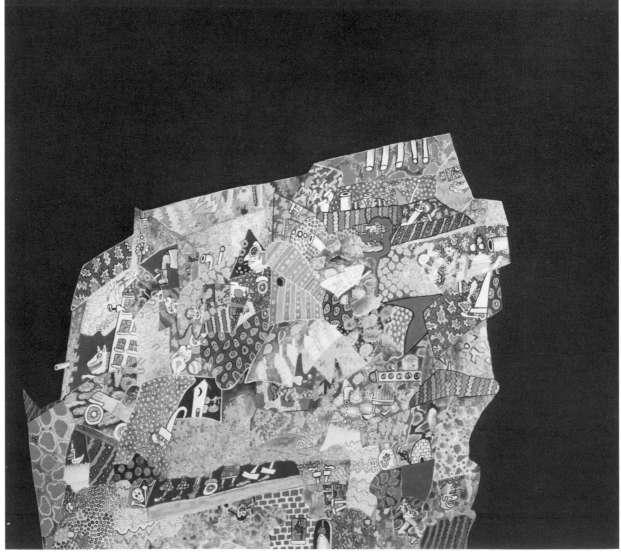

Ronald Markman
GOOD EARTH, 1979
Acrylic on canvas, 45 × 50 in.
Terry Dintenfass Gallery

As documenter of Mukfa, Markman is himself not content to sit still. He does not just draw and paint the exploits of Poc Pocians and other Mukfites, but collages them, turns them into decorative patterns (using their taste for garish wallpaper to help in this respect), and even carves and assembles them in jazzy reliefs. And, somehow, the view out the window of a cozy domestic scene becomes all the more vivid for the real shutters swinging wide. No matter that the view is of a jungle scene replete with elephants, leopards, and a big game hunter or two; in Mukfa, reality is whatever reality feels like being. Ocean scenes off the Mukfa coast are similarly laden with gentle incongruities, the kind that a child might conjure but which parents would be afraid to tell about as bedtime stories. It's one thing to show a mermaid singing its siren song; it's another thing to show nearby a man in a bathtub entirely submerged, save for his feet. The ocean in a bathtub? Now *there's* a metaphor gone wild. It would be nice to think of Mukfa as a metaphor for the human condition, but we are just not that fortunate. It is a nice place to visit, and some people dream of living there.

Ronald Markman
STILLLIFE WITH CLOCK, 1980
Acrylic on wood, 28 × 43 in.
Terry Dintenfass Gallery

JOAN MATHEWS

Having participated in several of the more adventurous phenomena of the New York art world in the late 1950s and 1960s—the Tenth Street post-Abstract Expressionist scene, early anti-Vietnam War sentiment, the elusive proto-conceptual group Fluxus—Joan Mathews now combines in her work a sensitive mixture of personal expression and interaction with the urban world which surrounded her at least until she moved to Mexico late last year. Adhering to a format of great formal and material economy, Mathews—who grew up in Fort Wayne and attended Indiana University — evokes the urban ambience as a cascade of broken and interrupted signs and indicators, fragments of specific objects and appearances (such as subway plaques, hand-written notices, graffiti) and generalized excerpts (bricks, sidewalk textures) combining in carefully ordered but expansive wall installations. These are more than pictures, more than drawings; they are composite entries in an ongoing visual diary. Mathews is as willing to insert an apparently discordant, extraneous image or actual item; is as willing to skew the elements against one another, as a more traditional diarist would be to press a leaf in the pages of the diary after a day spent in the woods. Mathews has not spent her day in the woods but in the urban jungle, where the response is grander, sterner, more visually cacophonous and stimulating.

98

Joan Mathews
HEAD/BRICKS/AILANTHUS, 1982
Conte crayon, wax crayon, lumber crayon, ink and color photocopies, 13 parts, 90 × 54 in. overall
Collection of the artist

Still, Mathews herself is no coarse cab driver or street hawker; her native gentleness does dictate a certain delicacy in her rendering with the touch of her pencil, pen, or brush. Even when she resorts to the color-photocopy technique, giving the imagery thus reproduced a harshly-colored edge, the results are strangely and beguilingly soft. Mathews seems to be insisting that the city has a gentleness to it amidst its gruff hurly-burly, and if we look for it, or merely keep one eye cocked for it, we may find it.

I lived in Fort Wayne, Indiana from the age of about 2 until I was 22. During childhood my chief encouragement to produce art came from my parents. I spent a great deal of time drawing. The schools I attended in Fort Wayne offered little or nothing in the way of art instruction, but when I arrived at

Indiana University in Bloomington at the age of 17 intending to study commercial art I discovered a milieu where art really mattered. There I was introduced to fine arts and art history. My teachers were practicing fine artists and art historians, with strong connections to both the European and New York art scenes. The experience of studying with them was electrifying. I and a number of my classmates dedicated ourselves to becoming fine artists under the influence and with the encouragement of our teachers, a rather uncommon choice of professions at that time.

When I graduated I went to New York where I've spent practically all the intervening years. I've continued to make art and have met many important artists and others but I have never met a more stimulating, intelligent and influential group of people than those I studied with at Indiana University, both in fine arts and in "academic" subjects.

–JOAN MATHEWS

99

Joan Mathews
GOING TO WORK, 1982
Crayon and ink on paper, 4 parts, 72 × 30 in.
Collection of the artist

BRUCE NAUMAN

The oeuvre of Fort Wayne native Bruce Nauman has the formal variety to allow him to work in media as varied as plaster, neon, videotape, and acoustic panels, and to resort to shapes and contents as disparate as architecture, words, and body parts. That variety is the result of an active mind seeking constantly to transform the world, to effect alterations and aggrandizements of 'givens' through contextual rupture and actual metamorphosis. Nauman's thinking is basically sculptural. He fabricates objects, and in doing so tends to capitalize on the particular properties of the substances employed. But even in the mutest, most contextually opaque pieces there is a forceful intellect at work often inflected with a poetic bent. For instance, Nauman has recently undertaken odd constructions out of cast plaster, arranging the large units in structures that are usually hugging the floor. Although they are neither decorative nor utilitarian, they rhapsodize expansively on utilitarian objects, not on architectural monuments; furthermore, they do not try to *be* architectural monuments. The sculptural forms refer obliquely to their purported functions by modifying the effectiveness of the original

100

Bruce Nauman
PERFECT DOOR/PERFECT ODOR/PERFECT RODO, 1972
Neon, 3 parts, 21½ × 28¾ in. each
Leo Castelli Gallery

structures in carrying out these functions. This process also takes place in Nauman's word pieces, which are sculpted out of working neon and make object-presences out of non-objects. The word, an abstraction, is no longer abstract. His puns, hardly as complex or intellectual as a Duchamp *mot*, still upset normal language usage and meaning without quite contradicting it. Throughout his work, Nauman practices subtle subversion of form and meaning and content.

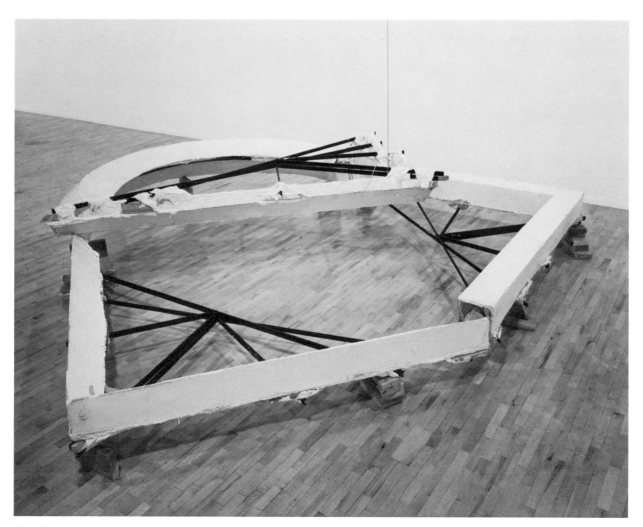

Bruce Nauman
MODEL FOR TUNNELS: ½ SQUARE, ½ TRIANGLE AND ½ CIRCLE WITH DOUBLE FALSE PERSPECTIVE, 1981
Plaster, steel, wood and wire, 35 × 187 × 176 in.
Leo Castelli Gallery

ISAMU NOGUCHI

What makes Isamu Noguchi universally recognized as one of the premier sculptors of the twentieth century is his ability to incorporate so many of the lines of sculptural reasoning of our time without seeming in any way eclectic. He draws quite plainly from his Japanese heritage and just as obviously from the European-American tradition of stone carving, in which he became interested during the four years he spent in and near LaPorte. Any one of his sculptures is a model of simplicity, but in its formal economy, it does not stand mute. A poetry of form pertains that is at once individual and modern. This poetry results from Noguchi's recognition that economy of form is a rule of thumb, not a goal—that one should no more hesitate to add than to subtract. Some of Noguchi's sculptural forms have been comparatively complex, and his increasing tendency to mix substances such as stone and metal, and even to refabricate the same form out of entirely different materials, indicates an aversion to the idea of purity for its own sake. Noguchi's active participation in the lively and decorative arts throughout his career has resulted from this aversion, just as his contributions to these other arts, which changed them the way his carving and molding has changed sculpture, was marked because of his taste for, rather than addiction to, simplicity. Noguchi has eschewed allegiance to any given idiom—although he has paid attention to many and contributed to at least as many—in order to follow his own vision of what must be called an organically reasoned sculpture.

With regards to your letter asking me for a statement on my years in Indiana, I should say I got there simply because of my mother. In Japan she had read an article in the Scientific American of those days, recounting an experimental school called Interlaken, between LaPorte and South Bend. There were 150 acres devoted to the teaching of children through involvement with manual work. The motto was, "To teach boys to know by doing." My mother was interested in education. She was a teacher of English in Japan and was dissatisfied with the

102

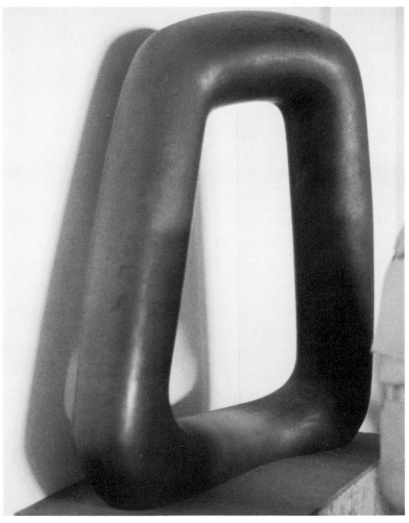

Isamu Noguchi
VOID, 1971
Bronze, 45¼ × 36 × 8¾ in.
Collection of the artist

curriculum there and she had even made an effort to teach me herself for one year. She also had me apprenticed to a cabinetmaker one summer in Chigasaki where we had built a house when I was eight years old. That is to say, she insisted I become involved in that building process and I did take a great interest in it. There was a garden there where we planted a number of peach trees and became involved with horticulture, getting cuttings of such plants as geraniums, roses and violets of which I had a good many.

Sometime later because of her having secured a position with a school in Yokohama, a girls' English language school, Miss Mander's, she got a house there and Chigasaki became a place to go in the summer. My previous contact of going to a local school in Chigasaki and even commuting from there during my mother's absence was cut. I was becoming less and less a part of the country; more a foreign Eurasian. It must have been for this reason that my mother decided to send me to America where there was less discrimination.

By the time I arrived in Interlaken it had become a summer camp of which I became a member. There were other boys like myself from other lands since the school had been founded by a Dr. Edward Rumley who had an interest in children from many parts of the world. For a while I roomed with a Philippino boy named Emilio Agpauan who had been brought to the San Francisco Fair as an example of a wild boy from the Igorots for display. Unfortunately, Dr. Rumley had got into trouble with the government and Interlaken was taken over as a motor truck training center for the army and I was left stranded.

I became a kind of handy-boy while going to school in Rolling Prairie. It was only later that year that Dr. Rumley discovered me there and put me to board in the home of a Swedenborgian minister in whose family I gradually became acclimated to people in this strange land. I worked in the sorts of jobs that little boys then commonly worked, taking care of furnaces, delivering newspapers, and mowing lawns. My memory is one of a gradual developing awareness and change of identity. I became interested in mechanical solutions such as an automatic phonograph and a submarine which would suck its way through water. One summer I was an assistant brick layer and later Dr. Rumley got me a job in a medical laboratory. I also assisted in the farming of peonies. This is how I became a Hoosier and a native American—slowly and with no fixed plan.

–ISAMU NOGUCHI

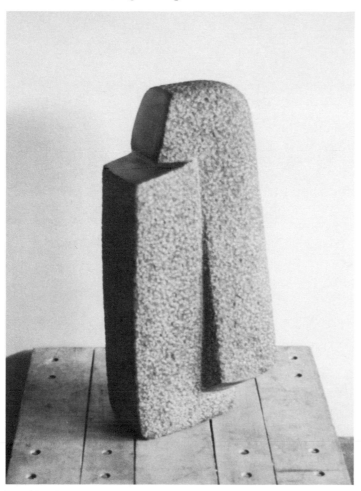

Isamu Noguchi
BINDU, 1966-67
Basalt, 25¼ × 11 × 6¼ in.
Collection of the artist

103

GEORGE RICKEY

The work of George Rickey seems to be a meeting place for the engineer and the poet, with the resulting hybrid being something as akin to magic as to sculpture. Rickey's longtime adherence to the task of making sculpture that incorporates movement is a little short of audacious. When he began fabricating kinetic structure in the 1940s, only Calder and a few incidental sculptures by various other artists provided aesthetic groundwork for moving three dimensional sculptural objects. But Rickey gravitated naturally to this line of reasoning, and to this kind of work. His sharpest boyhood memories are of big engines on steamers and little ones in toys in Scotland, where his family moved from his South Bend birthplace when he was seven. Rickey returned to Indiana to teach for several years in Bloomington. It was at this time that his boyhood fascination with machines matured into a desire to make machines. But the curiosity with machines never left, no matter how proficient he became, and his machines have always been explications of operation, of the way things work in tandem and accommodate, or must be made to accommodate, one another. Rickey has usually worked with the simple, refined elements of planes, lines, cones and geometric forms which could be said to describe movement in their very shape and logic, even as they move or are subjected to motion. The motivating force in every one of Rickey's sculptures is the wind, of course; if he had been fascinated by motors as a child, he has not depended on them as an adult, but prefers to let natural causes provoke his structures into kinesis. Rickey is known for a long-standing association with Constructivist art and thought, having carefully assembled a collection of geometrically-based art which he later donated to a major museum. But the language of Constructivism, the points and lines on planes which characterize this persistent strain in modern art, is incidental to Rickey's real interest which is the giving of form to movement itself.

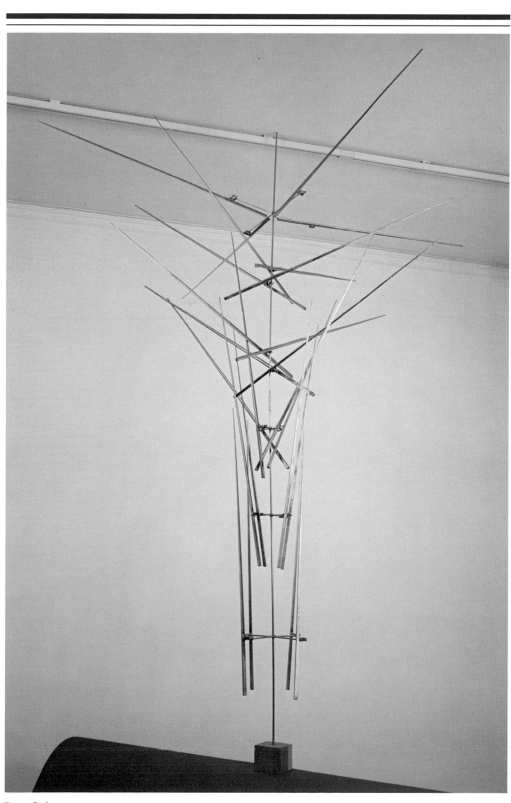

George Rickey
TWENTY-FOUR LINES, 1968
Stainless steel, 96 × 36 × 36 in.
Collection of the artist

My first serious engagements with kinetic sculpture were made soon after coming back in 1949 to Indiana University to teach in the art department (I was born in South Bend but whisked off to Scotland at age 5). I had been a painter for twenty years but had begun to discover, partly through technical work with remote-control gunnery systems on B29 bombers in the Army Air Corps, that I had some dexterity in my fingers and some rational analysis in my head that I wasn't using in my somewhat expressionist painting. Those first ventures were, perversely, with biomorphic forms cut from window glass and so hung on wires that they tinkled like the Chinese windbell that I had seen hung overhead as a child in a neighbor's front hall, responding whenever the front door was opened.

I had mastered curvilinear cuts with the glass cutter fairly readily but I was courting disaster with gravity—one false move or jiggle and I was left with half a bushel of sharp shards to sweep up. I think only one of these glass sculptures has survived, in the house of the composer Bernhard Heiden. After a year of trauma with tinkle and crash, I turned to metal. I found scraps of stainless steel on the University dump; that is still my metal. However, for ease of manipulation I also worked with brass, which I could buy locally in various forms and could easily cut, drill, tap, and fit together in precise structures. I had the idea then of developing a machine aesthetic with parts bolted together with tiny hex head bolts.

I also became interested in making indoor sculptures for the spaces nobody wanted to use. Hence the title of one of these; I later made sculptures for the overlooked corners of rooms and for the vertex where the ceiling meets the corner; I noted the conjunction of three surfaces at 90° as half a cube and made a kinetic completion of that cube.

This "Machine for a Low Ceiling," made in the temporary war surplus wooden building Indiana University offered me as a studio, was one of three or four variations on the theme. This one had a curious history, with a happy ending. I sold it to Mr. Kintner, president of NBC, and installed it in his office in Radio City. He retired, went to Washington, the sculpture with him. Imagine my surprise to receive a phone call years later from a young Washington collector who had come into possession of this sculpture, second, third, or fourth hand (who knows?) and by this time apparently anonymous. However, there was a signature on it, which the new buyer found. He phoned me for verification, and arranged to bring it to me for assembly as he didn't know how the parts fitted. It was complete and in perfect condition, but, assembled, was too big for his house, though his ceiling must have been low enough. To make us both happy I proposed that I make him a new sculpture, fitted to his space, in exchange for this one from my early days.

So I have this, and he has his.

–GEORGE RICKEY

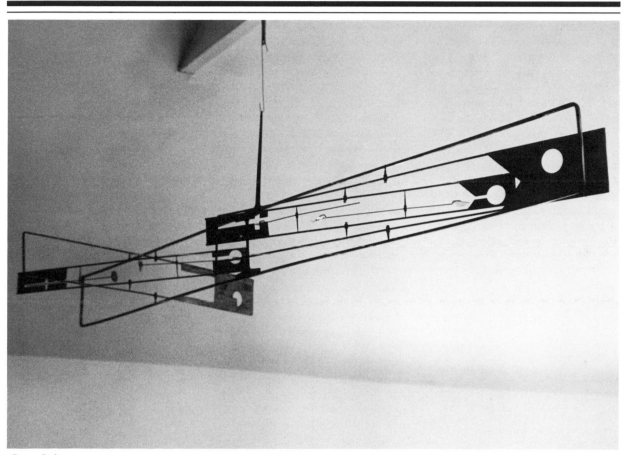

George Rickey
MACHINE FOR A LOW CEILING II, 1953
Brass, 72 in. wide
Collection of the artist

KAY ROSEN

In the past several years Gary resident Kay Rosen has taken her process-oriented conceptual art far from its original basis in measuring and counting mundane aspects of real life. In her most current work Rosen no longer concentrates on the quotidian activities she had previously diagrammed and notated, but on more transformative interactions with that most quotidian of phenomena, ordinary language.

Proceeding from a standpoint heavily oriented toward notation, Rosen has created an ongoing series of what might be classified as visual poetry, except that it is not poetry, it is essay, prose, and philosophical— actually linguistic—proposition. In this way Rosen can indulge a taste for plays on words while illuminating some curious and too-often forgotten aspects of language in general, and the English language in particular.

Rosen's strong graphic sense is also exercised in these neatly rendered but complex drawings. The visual component of the statements must be coherent with the form assumed by their typography while it formulates diagrammatic demonstrations of the propositions that the statements discuss. This superimposition of word and usually linear image must be logical, if not seamless. Rosen cannot depend on typography itself to explicate her statements; typography is evidently not enough. The collective title for these drawings, in their 'looked-at' form as well as for the exquisite book that reproduces them in their 'read' form, is *Lines on Lines.* The double meaning of "lines" itself underscores Rosen's method of communicating. Which define which, the drawn lines or the written lines? It is a chicken-and-egg question.

108

THEY THOUGHT TWICE ABOUT SAYING THAT THEY THOUGHT IT A LAUGHING MATTER; BUT AFTER RETHINKING IT HALF SAID IT WAS UNTHINKABLE, AND THE OTHER HALF THOUGHT IT UNUTTERABLE.

In cartoons words and thoughts aren't given much weight encased as they are in balloons, clouds, and bubbles.

Kay Rosen
LINES: BALLOONS, CLOUDS AND BUBBLES, 1982
Typeset text and china marker on mylar overlay, 32 × 40 × 2 in.
Bertha Urdang Gallery

Sometimes I feel like a black sheep when I say I am from Gary. People always ask, "Ewe live in Gary?" No one ever asks, "Do ewe graze in Gary?" Or, "Is the grass greener in Gary?" They do ask, "Do bullets graze in Gary? Do bullets lodge in Gary?" Bullets, like diplomats, explorers and elks, lodge everywhere. Did Henry Cabot lodge in Gary? I doubt it. Neither did John Cabot nor Sebastian Cabot. Father Jacques Marquette, a French explorer, did lodge here temporarily. A nearby school, church and park are named after him; and his statue in the park attests to that fact. Art in the parque in Guerrey. The French influence is minimal, though. My work was somewhat minimal for awhile, but I do not think there is any connection between the two. Connections are hard to nail down if they are not tangible. I guess that is why there is a monument to Father Marquette—to establish a concrete connection with the past. I do not know whether or not the statue is concrete; but I do know it has not weathered because it is spray-painted a copperish bronze color, and the paint has not cracked, faded or peeled over the years.

–KAY ROSEN

A queue
is a line of people
which grows at the rear.
Although the letter "q" is a
finite line, the repetition of "ue ue"
suggests that the word might be adjustable
at the end; equivalent to the length of the line.
One might stand in a *que* for five minutes;
in a *queue* for an hour;
in a *queueueue* for hours.
As for its homonym, a repeated cue
to an actor is not a cueue, but a *rescue*,
which elicits yet one more homonym than *kyou*.

Kay Rosen
LINES: QUEUE, 1982
Typeset text and china marker on mylar overlay, 32 × 40 × 2 in.
Bertha Urdang Gallery

TOM SHELTON

Tom Shelton has been living and working in Columbus since 1976, when he enjoyed the distinction of being the first artist in the country to serve as "artist-in-residence" for a whole town. At first glance, Shelton's work seems to be a particularly deft and sophisticated trope on the traditional stylizations of American folk painting. The flattened perspectives and symmetrical images which characterize the landscape painting of American naifs, from the Moravian painters of the late 18th century to the black folk artists still working throughout the South and Midwest, are recalled distinctly by Shelton's marvelously meticulous compositions. But something almost sinister pervades Shelton's pictures casting a sense of an ulterior plan that imparts to these scapes a rigor far beyond the domestic or utopian aspirations of his folk-art models. Shelton does have a master plan or, more accurately, an overriding plan for each picture. Each is a fleshed-out diagram of a natural statistic, a piece of comparative history or a fact of daily life or both. The progress of civilization, for instance, is measured in a charming painting of various ships on the high seas, the measurements represented by the length and shape of the waves and relative placement of the ships. Or, the daily habits of the fauna in a certain part of the country are indicated by the placement of those animals, and the placements of the traps set out for them by hunters, in their native woods. There is usually additional information in the margins of Shelton's pictures, footnote-like annotations or information which help coordinate the subtle function of vertical and horizontal placement. Each Shelton painting in effect charts what it depicts, or vice versa. Shelton's pictures are like the fanciful maps of the Renaissance and Baroque eras, cartographic marvels in which "real" whales the size of Florida dance off the Brazilian coast in clear indication of *terra incognita*. Only Shelton's *terra* is decidedly *cognita*—at least to anyone clever and patient enough to decipher Shelton's cryptic but logical encodings.

My family and I have lived in Indiana (Columbus) since 1976. Before that, we lived in Ohio.

We are living here today because we and our children have friendships, we have a home we like and a small yard we enjoy working in; I have an inexpensive studio several blocks away, and my wife has a job she likes; there are woods and hills nearby and a good library.

Whenever, in the past, I have lived around others who have an interest in art, I have begun to compete (sometimes only in my mind) with them for originality, knowledge, uniqueness, praise. I have been dependent on what others think of the work. I want to learn not to do this. I want to learn to live in better harmony with the things and people around me and to accept the pictures I do as simply pictures.

Living where we do is probably good for me right now.

–TOM SHELTON

Tom Shelton
SWIMMERS, 1982
Acrylic on canvas, 72 × 54½ in.
Collection of the artist

111

HOLLIS SIGLER

The current surge in eccentric figurative painting has taken on special resonance in the Chicago area, where offbeat figure painting has long been not just accepted, but predominant. Current Chicago figure painters, following in the tradition, if not the approaches, of their predecessors in the Monster School, Hairy Who, and Imagist groupings, have evolved an intensely personal, and therefore disarmingly intimate, way of addressing and utilizing the figure. Hollis Sigler, a native of Gary, is prominent among such younger Chicago-area painters, gaining national and even international note for her awkwardly-rendered rooms and similarly crude outdoor scenes, spare of details but abrim with personal associations. These associations are embodied in every item in the picture; every piece of furniture (beginning with the bed, but never confined to it), every mantle object (vases, lamps, standing pictures), even every architectural detail (doors, windows) and decorative accoutrement takes on a personal emphasis. These scenes are filled with a dreamy desolation, their emptiness and the halations of artificial lights making the rooms glow and swell as if seen in a hallucination. The intent is not merely to evoke a dream or memory, however, but to document, nearly diaristically, life's real and imagined events. These events tend toward the romantic or even the metaphysical. When Sigler is not setting the stage for trysts and the inevitable broken hearts, she is imagining herself, or her pictorial ciphers, able to fly, to dance freely, to dream dreams into which the dreaming figure can step. These images are described with a sure but plodding

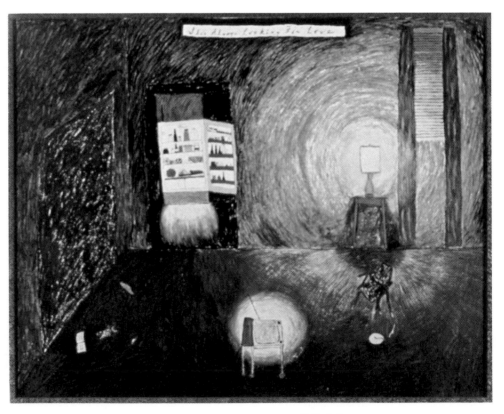

Hollis Sigler
SHE WAS ALWAYS LOOKING FOR LOVE, 1982
Oil on canvas, 49½ × 61 in.
Dart Gallery and Barbara Gladstone Gallery

112

directness with thick, broadly and heavily worked oil impasto. There is a knowing naivete in the emblazoned titles and streaming banners at the top of each picture. Even the frames, wide, clunky, often painted or built with extraneous carved devices, add to the funk and enhance the deliberate abandonment of sophistication. Sigler has obviously been looking at true naifs, as Chicago figure painters are wont to do, and she proves herself gifted at understanding what these naifs are all about pictorially and narratively.

All my family lived in Indiana. My grandparents lived in Kokomo and Indianapolis. I was born in Gary. Was raised for the first light years of my life in Crown Point. Then my folks moved away from Indiana. I was heartbroken. As far as I was concerned, it was the only place I wanted to be. I would lie awake at night scheming on how I could get back to Indiana. I was going to mail myself back to my grandmother's farm. The fantasy was to put myself in a box with a few provisions. (I was a small child, very skinny.) For some reason, the provisions were bananas. I must have thought I was shipping a monkey. There was a flaw. What *would I do when I had to go to the bathroom? I abandoned the plan. But not the dream. I've always wanted to go back to my grandmother's farm. It was her farm that I have been in love with. It was home. In my mind's eye I can still see it. At night, I still dream about being there. In a lifetime of dreams, it is the one constant symbol. Moving away from Indiana has had a big influence on my life. My life seems to be about trying to find home, that safe, secure place I knew.*

–HOLLIS SIGLER

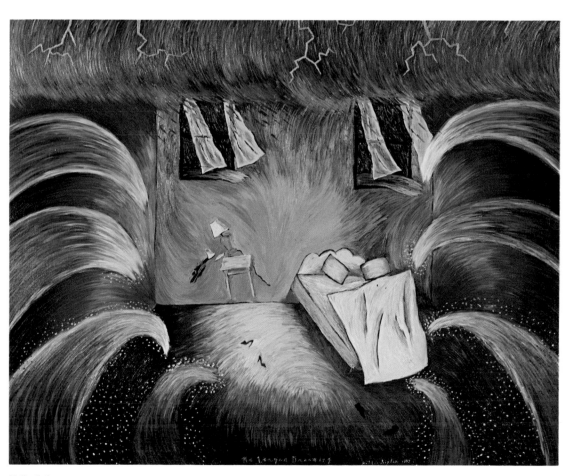

Hollis Sigler
NO LONGER DREAMING, 1983
Oil on canvas, 50½ × 62 in.
Barbara Gladstone Gallery

KEVIN TEARE

The contemporary world is filled with signs and symbols—those abstracted shorthand devices which indicate everything from geographical detail to marketing identification, from private code to universal direction (e.g. traffic signs), from elaborate language to simplified image. The increasing presence of such signs and symbols in our communication-oriented society has not escaped the notice of artists. Indeed, the vast volume of modern-day ciphers provides the visual language and subjective commentary for many recent art styles, including Pop Art, New Image Painting, Conceptual Art, and even, obliquely, the "neo-Expressionists." Fitting comfortably into none of these categories, New York painter Kevin Teare still concentrates on the presence of signs and symbols in present-day American life. Teare, born and raised in Indianapolis and educated in Muncie and Bloomington, bases his whole approach on the formal presentation (often amplified) and contextual meaning (often skewed but never obscured) of images as direct in design, yet redolent in significance, as maps of Medieval battles, corporate logos, and Teare's own cryptographic figures. Unlike many other current artistic exploiters of the sign-filled world, Teare is not content merely to reproduce sign systems, or to parody them, or even to invent his own. He insists that each cipher works as part of, or even helps generate, visual compositions of great boldness and elegance. At the same time, Teare does not snatch random symbols from street signs, advertisements, or movie marquees and incorporate them into his paintings just because they look nice and have a vaguely intriguing air of our high-tech life about them. As compositionally sound as every sign is in Teare's pictures, its presence is justified basically by its symbolic or signatory meaning—inflected, inevitably, with the artist's own associations and also with those of the viewer.

116

Kevin Teare
MYSTERY TAKES A WALK, 1982
Oil and wax on paper, 60 × 60 in.
Collection of the artist

In Indiana you go home to be surprised.

A wide test market cut a swath through the middle of the state, canvassing the plain from Terre Haute to Ft. Wayne. We got toothpaste in stripes and orange juice for astronauts.

When all the white houses turned yellow and the horizon went mauve to violet, you made your way to the cellar and listened for the "freight train." Those lucky enough to live near the bank could lock themselves in a vault, while others turned to prayer.

Indianapolis was the worlds' largest one-horse town. There, in the 1950s, my sister shared a cheeseburger deluxe with James Dean at Downey Dunker Donuts. There a teen could eat.

Foreign race car drivers greased their hair straight back and turned left, leaving town a few hundred thousand dollars richer for their troubles. Hoosiers seemed to be practicing the trickle down theory in "culture." Most of the Gustons, Burchfields or Morandis we got were in magazines. The Brooks Robinsons, Ernie Banks and Art Quirks were televised from real cities far away. Most of the Beatles, Coltrane or Messiaens were on black vinyl beneath the shrink wrap. One learned young to make one's own excitement or to appreciate good packaging. If as William Carlos Williams said: "We are about these things" is true, then the parade of products marched past my puberty, with it's relentless salvo of the "New and Improved," was responsible for pushing one into the "inner lair."

When you're young, an international port is wherever you're from. Indiana, like the world, is around.

–KEVIN TEARE

117

Kevin Teare
MOTORCADE ROUTE WITH PILLBOX HAT, 1982
Oil and wax on paper, 82 × 60 in.
Collection of the artist

WILLIAM T. WILEY

To many minds, William T. Wiley *is* West Coast Funk, the way Willem de Kooning is Abstract Expressionism or Andy Warhol is Pop Art. Bedford-born Wiley's irrepressible goofiness brims in every one of his works, no matter how serious the topic or how brilliant the draughtmanship. Visual and verbal puns abound in profusion so great that their presence, more than what they say, is what becomes important. Coarse and elegant rendition, obscure and obvious subject matter, intensely personal matters and worldwide politics, flat drawing and painting and sculptural substances, even *objets trouvés* seem to fall together in Wiley's work, not just depicted as 'falling together' but deliberately, in seeming anarchy. It is, of course, a very knowing anarchy, the same anarchy,

driven by inner logic, that motivated Pollock and has compelled any successful practitioner of an expressive aesthetic.

Wiley has been working in this manner, this kitchen-sink approach to art-making, for at least two decades. Having emerged from Bay Area Abstract Expressionism and its abiding allegiance to biomorphic form and the manual mark, Wiley was at the forefront of a group of artists who took this allegiance a step further, and dared to have a good time doing so. There seem to be several motivating factors in Wiley's work and, by extension, in Funk work in general: the biomorphic formal vocabulary; the jocular attitude toward art that masks a relaxed but serious attitude toward life; a juxtaposition of technical deftness and knowing crudity. But most important is the underlying point of view which makes all these things pertain. It is the attitude that life is complex, simultaneous, and many-qualitied, and there is no reason to distill art out of it; art can be a slice of life, a complex cross-section of existence reconsidered by the artists, and by the viewers in their own puzzlement, pseudosophisticated offense, and Zen satori of comprehension.

WHO THE QUARRY WHO THE QUARRIED . . . SPEAK

WHEN ASKED A QUESTION LIKE THAT–MY BRAIN FLOODS AND OVERDOSES WITH IMAGES MEMORIES FEELINGS.

HOW TO EXTRACT SOME WORD OR WORDS? THEME? FROM ALL OF THAT IN THE INTEREST OF . . . ? TRUTH? SOURCE? LAUDATORY LINKAGE? HISTORY? JUSTICE? DEMOCRACY? FEAR? ORIGIN? THE PLANET . . . LIFE . . . HUMANS?

I TRUST–AND SOMETIMES KNOW . . . AT LEAST SOME OF THAT IS REFLECTED IN MY ART.

THE WHY OF IT . . . REFLECTING ON PRESENCE AND CONSCIOUSNESS. TO THINK THAT WE ARE HERE? AND CAPABLE OF CAUSE. WHAT DOES ANY OF THAT HAVE TO DO WITH INDIANA? I DON'T KNOW. BUT I WOULD TAKE THIS OPPORTUNITY TO SAY THANKS FOR THE WALL BASH AND PLACE TO BEGIN . . . A STATE OF MIND. WHOSE YOUR HOOSIER

–WM. T. WILEY 84

118

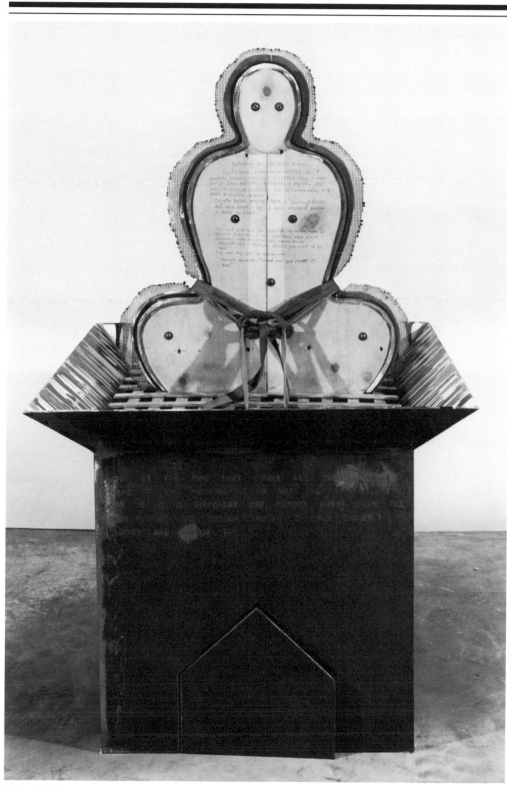

William T. Wiley
BOO DADA BAR BQ, 1982
Wood, brass, steel and paint, 53 × 33 × 33 in.
Allan Frumkin Gallery

TOM YOUNG

A native of Indianapolis and a graduate of the John Herron School, Tom Young is something of an Abstract Expressionist *manqué*. He was in New York in the late 1950s and early 1960s, exhibiting on Tenth Street and frequenting the Cedar Bar where his good friend Franz Kline held forth. Young's aesthetic is decidedly Abstract Expressionist although, like many of his Tenth Street colleagues, it has lost its anxious flavor and takes on formal aspects that were labelled 'hard edge' in the early 1960s. Color in Young's work tends to be the paramount element; this would obviously urge him to a less painterly, more expansive and formally clear, uncomplicated style. In some of his recent painting, Young, who now lives and teaches in New Orleans, seems to be taking up where Robert Motherwell left off, posing massive silhouettes against areas of spectacularly vivid color, or vice versa.

In other works, though, Young reveals himself to be more circumspect a picture-maker, linking together large and small color areas in playful but soberly-organized compositions. Even in his darkest paintings Young displays a formal and coloristic exuberance, a legacy of Action Painting—Harold Rosenberg's term for the broad, vigorous style shared by de Kooning and Kline — which Young continues and extends rather than that of Abstract Expressionism in general. Although the quieter, more philosophical and introspective mode exemplified by Mark Rothko and Barnett Newman was also a factor in Abstract Expressionism, such restraint is not in Young's method. His expansive paintings cohere because Young seems to have a natural sense of pictorial order. He does not need to impose one. Style is not calculation in Young's case, it is gesture.

In 1930, when I was six years old, my family moved to Indianapolis from Huntington, West Virginia. I remember working with plastiline clay in the first grade and making a bargain with the son of the custodian of the apartment house in which we lived. I was to teach him to draw if he would teach me to read and write. His father, who also worked at the Duesenberg automobile plant, pinned up some discarded proposed body drawings on the wall of their apartment. They were beautifully done in colored pencil (perhaps by Gordon Buehrig himself). I was enthralled by them. I still remember them in detail and consider them as being responsible for my first important aesthetic experience.

In the fourth grade I was declared to be "an artist" by Miss Holden. In junior high I received a scholarship to the John Herron Art Institute to attend a Saturday drawing class. I recall drawing from huge, exact-sized plaster casts of Venus de Milo and Verrochio's equestrian monument of Colleoni and falling in love at first sight with a reproduction of the bust of Queen Nefertiti.

At Shortridge High School I studied art with Mr. Wheeler, who encouraged me to continue in art and influenced my later decision to live in New York by telling me of his experiences there when he shared a studio with Vachel Lindsay.

I owe a great deal to the early exposure, training, and encouragement which I received in Indiana.

–TOM YOUNG

120

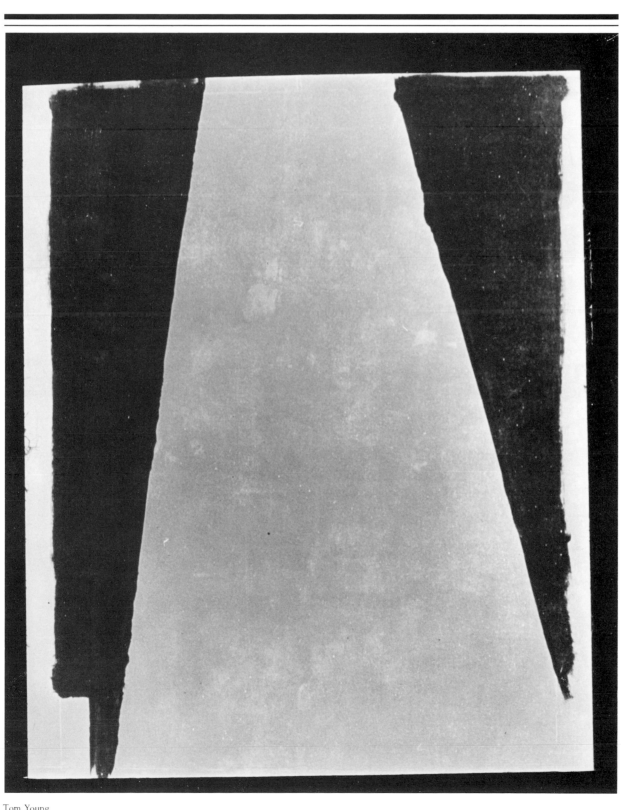

Tom Young
BIG RED, 1981
Polyurethane on canvas, 89 × 73 in.
Collection of the artist

CHECKLISTS OF THE EXHIBITION

The checklists for both sections of the exhibition follow. All dimensions are listed as height x width x depth, all are in inches and represent unframed sizes or sculpture without presentation pedestals. Objects comprised of more than one distinct piece are listed as "each" unless they are of various sizes, in which case the overall dimension is listed.

THE GOLDEN AGE OF INDIANA LANDSCAPE PAINTING

J. OTTIS ADAMS
The Hermitage, 1901
oil
18 x 24''
Permanent Collection of the Fort Wayne Museum of Art 1922.26
Across the Valley – Brookville, 1904
oil
32 x 27''
Permanent Collection of the Fort Wayne Museum of Art 1956.01
The Ebbing of Day, 1902
oil on canvas
34 x 48''
Courtesy Ball State University Art Gallery, Muncie, Indiana; Permanent loan from the Frank C. Ball Collection, Ball Brothers Foundation
Brookville, n.d.
oil on canvas
32 x 22''
Collection Mr. and Mrs. Richard E. Wise, Union City, IN
August Sunset, n.d.
oil on canvas
18 x 28''
Collection Indianapolis Museum of Art; Gift of Robert Brady Adams, Allan A. Adams and Edward W. Adams

WAYMAN ADAMS
Haying in Indiana, n.d.
48 x 29¾''
Collection Mr. and Mrs. Richard E. Wise, Union City, IN

ADAM ALBRIGHT
Log in the Stream, n.d.
oil on canvas
48 x 35''
Collection Union League Club of Chicago
Quoits, 1908
oil on canvas
20¼ x 26¼''
Collection Pennsylvania Academy of the Fine Arts, Philadelphia; Gift of Ivan LeLorraine Albright

GEORGE AMES ALDRICH
Untitled, n.d.
oil on panel
38 x 55¼''
Collection The Snite Museum of Art, University of Notre Dame, IN
Winter Landscape with Stream, n.d.
oil on canvas
30¹/₁₆ x 36⅛''
Collection Mr. and Mrs. Clarence W. Long, Indianapolis, IN

L. CLARENCE BALL
Kankakee Marsh, n.d.
watercolor
8½ x 5¾''
Collection Mr. and Mrs. Federick C. Elbel, South Bend, IN
Kankakee Marsh, n.d.
watercolor
5¾ x 8¾''
Collection Mr. and Mrs. Frederick C. Elbel, South Bend, IN
Felling the Bee Tree, n.d.
oil on canvas
60 x 84''
Collection South Bend Public Library, IN

JOHN ELWOOD BUNDY
Landscape, 1901
watercolor and pastel on board
4½ x 10¹/₁₆''
Permanent Collection of the Fort Wayne Museum of Art 1948.05
The Monarch Beech, n.d.
oil on canvas
28 x 35''
Collection Indianapolis Museum of Art; Gift of the Benjamin Harrison School
Indiana Dunes, 1924
oil on canvas
28 x 28''
Courtesy Art Center, Inc., South Bend, Indiana; Long term loan from The Snite Museum of Art, University of Notre Dame; Bequest of Peter C. Reilly
Winter Scene, 1914
oil on canvas
15⅞ x 20⅜''
Collection Mutual Hospital Insurance, Inc., Indianapolis, IN

VERALDO CARIANI
The First Snow, n.d.
oil on board
17 x 20''
Collection Dr. and Mrs. Paul W. Elliot, Lafayette, IN

CHARLES CONNER
The River Road, n.d.
oil on board
8¾ x 12''
Collection Mr. and Mrs. Gordon Gates, Indianapolis, IN

HOMER DAVISSON
Village Path, 1920
gouache on board
21 x 17¼''
Collection Mr. and Mrs. Richard E. Wise, Union City, IN

FRANK DUDLEY
One Winter's Afternoon, n.d.
oil on canvas
37½ x 58½''
Collection Union League Club of Chicago

WILLIAM FORSYTH
White River Valley, circa 1934
watercolor on paper
22¼ x 15⅝''
Permanent Collection of the Fort Wayne Museum
of Art 1935.02
Girls Bathing in a Pool, n.d.
oil on canvas
24 x 32''
Collection Indiana State Museum, Indianapolis, IN
Our Yard, 1900
oil on canvas
20 x 24''
Collection Penny Ogle, Indianapolis, IN
Sheep, 1927
oil on canvas
31 x 42½''
Collection Indiana State Museum, Indianapolis
Rural Village, Corydon Indiana, n.d.
oil on canvas
30 x 42''
Collection Mr. and Mrs. Richard E. Wise, Union
City, IN

ALEXIS FOURNIER
Autumn in Brown County, n.d.
oil on masonite
24 x 26''
Collection The Snite Museum of Art, University of
Notre Dame, IN; Gift of Mr. and Mrs. Judd
Leighton

FRANK GIRARDIN
Covered Bridge, n.d.
oil on canvas
23½ x 41½''
Collection Art Association of Richmond, IN; Gift
of Mrs. John B. Dougan

MARIE GOTH
Landscape with Cabins, n.d.
oil on board
20 x 16''
Courtesy Jay and Ellen Carter Art and Antiques,
Nashville, IN

CARL GRAF
Autumn Landscape, 1904
oil on masonite
17 x 22''
Collection Indiana State Museum, Indianapolis
Landscape – Brown County Scene, 1936
oil on board
13¹/₁₆ x 16¹/₁₆''
Collection Anderson Fine Arts Foundation, Inc.,
Anderson, IN
Brown County Cellar House, n.d.
oil on masonite
22⅞ x 29⅞''
Collection Mr. and Mrs. Richard E. Wise, Union
City, IN
Indianapolis Street Scene – The Vendor's Stand, n.d.
oil on canvas
22½ x 30''
Collection Mr. and Mrs. Richard E. Wise, Union
City, IN

LOUIS O. GRIFFITH
Owl Creek Valley, n.d.
oil on canvas
24 x 30''
Courtesy Jay and Ellen Carter Art and Antiques,
Nashville, IN
Owl Creek Valley Farm, n.d.
oil on canvas
20 x 24''
Collection Mr. and Mrs. Frank R. Stewart,
Spencer, IN

RICHARD B. GRUELLE
The Canal, Morning, 1894
oil on canvas
32 x 38''
Collection, Indianapolis Museum of Art; The John
Herron Fund
On the Canal, n.d.
oil on canvas
17½ x 32½''
Collection Mr. and Mrs. Richard E. Wise, Union
City, IN

LUCIE HARTRATH
Autumn Pageant, n.d.
oil on canvas
42 x 42''
Collection Union League Club of Chicago

JOHN W. LOVE
The Sycamores, 1878
oil on canvas
29½ x 24½''
Collection Indianapolis Museum of Art; The John
Herron Fund

ADA SHULZ
Two Children in a Field, n.d.
oil on canvas
29 x 26''
Courtesy Anonymous Collection, IN

ADOLPH SHULZ
The Old Ogle Homestead, n.d.
oil on canvas
40 x 48''
Collection Indiana State Museum, Indianapolis
Summer Queens, n.d.
oil on board
30½ x 36''
Collection Indiana State Museum, Indianapolis
Creeping Shadows, n.d.
oil on canvas
30 x 40''
Collection Indiana State Museum, Indianapolis
Home Sweet Home, 1933
oil on canvas
30 x 36''
Courtesy Jay and Ellen Carter Art and Antiques,
Nashville, IN

WILLIAM M. SNYDER
Autumn Beeches, n.d.
oil on canvas
16¼ x 13¼''
Collection Adam and Jack Kline, Indianapolis, IN

OTTO STARK
The Net, 1900
oil on canvas
27 x 22¹/₁₆''
Collection Mr. and Mrs. Clarence W. Long,
Indianapolis, IN
Fast Mail, 1895
oil on canvas
20 x 28''
Collection Dr. Wally Zollman, Indianapolis, IN
Tired Out, 1894
oil on canvas
32 x 52''
Collection Emmerich Manuel High School,
Indianapolis Public Schools, IN
Wet October, 1917
oil on canvas
20¼ x 15¾''
Collection Mr. and Mrs. Gordon Gates,
Indianapolis, IN
Sunflowers, 1911
gouache on paper board
22½ x 15¾''
Collection Mr. and Mrs. Gordon Gates,
Indianapolis, IN

123

William Forsyth

THEODORE C. STEELE
The Old Mills, 1903
oil on canvas
30¹/₁₆ x 45⅛''
Collection Mr. and Mrs. Clarence W. Long,
Indianapolis, IN
Snow on the Campus, 1895
oil on canvas
18 x 28''
Collection Indiana State Museum and Memorials,
Nashville, IN
Houses in the Distance, 1906
oil on canvas
30 x 45''
Collection Indiana State Museum and Memorials,
Nashville, IN
Trees in the Fall/A Forest Veteran, 1917
oil on canvas
30 x 40''
Collection Indiana State Museum and Memorials,
Nashville, IN
Pleasant Run, 1885
oil on canvas
19¼ x 32½''
Collection Indianapolis Museum of Art; Gift of
Carl B. Shafer
The Bloom of the Grape, n.d.
oil on canvas
30⅛ x 40⅛''
Collection Indianapolis Museum of Art; Bequest of
Delavan Smith
Summer Days in Vernon, 1892
oil on canvas
22¼ x 40''
Private Collection, Zionsville, IN
Winter Scene, 1926
oil on canvas
20 x 28''
Collection Indiana State Museum, Indianapolis
Whitewater Valley, 1889
oil on canvas
22 x 29''
Collection Ball State University Art Gallery,
Muncie, Indiana; Gift of Mrs. Edmund Burke Ball
Oaks at Vernon, 1887
oil on canvas
30 x 45''
Collection Indianapolis Museum of Art; The John
Herron Fund

WILL VAWTER
Scene of an Alley, a Car, and Some Buildings, n.d.
oil on canvas
30½ x 36½''
Collection Greater Lafayette Museum of Art, IN
Oil Study–Willow Trees, 1915
oil on cardboard
11¼ x 14½''
Collection Indiana State Museum, Indianapolis

INDIANA'S MODERN LEGACY

ROBERT BARNES
Parting Peacock, 1979
oil on cavnas
65 x 80''
Courtesy Allan Frumkin Gallery, New York
Ursus, 1982
oil on canvas
69 x 81''
Courtesy Allan Frumkin Gallery, New York

VIJA CELMINS
House #2, 1965
oil on wood and cardboard
12 x 9 3/4 x 7''
Private Collection, New York
Untitled (Big Sea #2), 1969
graphite on acrylic ground on paper
34 x 45''
Collection The American Telephone and
Telegraph Company, New York

JOHN CHAMBERLAIN
Idle Worship, 1980
painted and chromium plated steel
65½ x 8½ x 29''
Courtesy Xavier Fourcade Gallery, New York
Impurient Whey, 1982
painted and chromium plated steel
109 x 74 x 51''
Courtesy Xavier Fourcade Gallery, New York

GEORGE DEEM
Frames, 1982
oil on canvas
50 x 50''
Courtesy Sid Deutsch Gallery, New York
*Mayakovsky in a Bulldozer in Vermeer's Small Street in
Delft*, 1980
oil on canvas
50 x 50''
Collection of the artist
Simple as Mooing, 1982
oil on canvas
48 x 42''
Collection of the artist

WILLIAM DOLE
Criteria, 1979
16½ x 24½''
Courtesy Staempfli Gallery, New York
Dia Pason, 1979
collage
10¼ x 12¼''
Courtesy Staempfli Gallery, New York
Mandarin II, 1980
collage
12 x 10''
Courtesy Staempfli Gallery, New York
Ergo, 1981
collage 12 x 10''
Courtesy Staempfli Gallery, New York
Under the Rubric, 1981
collage
24½'' x 16½''
Courtesy Staempfli Gallery, New York
Ipso Facto, 1982
collage
12 x 17''
Courtesy Staempfli Gallery, New York
Brazen Image, 1982
collage
10¼ x 16¼''
Courtesy Staempfli Gallery, New York

JOHN DUFF
Melanesian Venus, 1982
fiberglas
65½ x 11 3/4 x 12¼''
Collection The Edward R. Broida Trust, New York
Sea Kite, 1983
fiberglas
60 x 12 x 17''
Collection of the artist

MARY BETH EDELSON
Spirals of Persephone, 1982
acrylic on canvas
132 x 72''
Courtesy of the artist
Horned One, 1982
oil on canvas
120 x 72''
Courtesy of the artist

ART GREEN
Critical Mass, 1982
oil on canvas on wood
55½ x 97¼ x 24''
Courtesy Phyllis Kind Gallery, New York and
Chicago
Risky Business, 1980
oil on cavnas
77 x 41''
Courtesy Phyllis Kind Gallery, New York and
Chicago

DAVI DET HOMPSON
Looks Are What I Know, 1984
acrylic on paper
84 x 60'' each of four parts
Courtesy of the artist

BRYAN HUNT
Lafayette Chair, 1981
cast bronze, limestone base
52 x 31 x 14'' (bronze)
86 3/4 x 31 x 24'' (overall)
Courtesy Blum Helman Gallery, New York

JIM HUNTINGTON
Chopper, 1981
granite and stainless steel, wood base
12½ x 13½ x 10''
Courtesy of the artist
Asking Eyes, 1977
marble, bluestone and cor-ten steel
86 x 31 x 19''
Courtesy of the artist
Arc Angel, 1982
granite and stainless steel
28 x 26 x 14''
Courtesy of the artist

ROBERT INDIANA
5, 1982
acrylic on aluminum, steel base
96 x 96 x 48''
Collection Melvin Simon and Associates, Inc.,
Indianapolis, IN
Terre Haute, 1960
oil on canvas
60 x 36''
Courtesy of the artist
The Small Diamond Demuth Five, 1963
oil on canvas
51¼ x 51¼''
Courtesy of the artist

124

WILL INSLEY
Volume Space Interior Wave, Isometric X-Ray View through the Ground, 1973/80-81
ink on ragboard
40 x 60''
Courtesy Max Protetch Gallery, New York
Volume Space Interior Wave, Section through Center, 1973/81
ink on ragboard
40 x 60''
Courtesy Max Protetch Gallery, New York
Volume Space Interior Swing, Isometric X-Ray View through the Ground, 1973/80-81
ink on ragboard
40 x 60''
Courtesy Max Protetch Gallery, New York
Volume Space Interior Swing, Section through Center, 1973/80-81
ink on ragboard
40 x 60''
Courtesy Max Protetch Gallery, New York

TERENCE LANOUE
Winterkill: Moonlight, 1981/1983
acrylic paint, graphite, metallic powders and other materials on canvas
95 3/8 x 83 11/16''
Courtesy Siegel Contemporary Art, Inc., New York
Kuala Lumpur, 1981/83
Acrylic paint, metallic powders and other materials on canvas
92 x 106 3/16''
Courtesy Siegel Contemporary Art, Inc., New York

JAMES MCGARRELL
The Grand Mediterranean, 1983
Oil on linen
41 x 80''
Courtesy Allan Frumkin Gallery, New York
Secret Still Life, 1981
Oil on canvas
45 x 93''
Courtesy Allan Frumkin Gallery, New York

RONALD MARKMAN
Good Earth, 1979
acrylic on canvas
45 x 50''
Courtesy Terry Dintenfass Gallery, New York

Stilllife with Clock, 1980
acrylic on wood
28 x 43''
Courtesy Terry Dintenfass Gallery, New York

JOAN MATHEWS
Head/Bricks/Ailanthus, 1982
conte crayon, wax crayon, lumber crayon, ink and color photocopies
13 parts, 90 x 54'' overall
Courtesy of the artist
Going to Work, 1982
crayon and ink on paper
4 parts, 72 x 30'' overall
Courtesy of the artist

BRUCE NAUMAN
Perfect Door/Perfect Odor/Perfect Rodo, 1972
neon
3 parts, 21½ x 28¾'' each
Courtesy Leo Castelli Gallery, New York
Model for Tunnels: ½ Square, ½ Triangle and ½ Circle with Double False Perspective, 1981
plaster, steel, wood and wire
35 x 187 x 176''
Courtesy Leo Castelli Gallery, New York

ISAMU NOGUGHI
Bindu, 1966-67
basalt
25¼ x 11 x 6¼''
Collection of the artist
Void, 1971
bronze
45¼ x 36 x 8¾''
Collection of the artist
Horizon Stone, 1982
granite and steel
20½ x 15 x 47''
Collection of the artist

GEORGE RICKEY
Machine for a Low Ceiling II, 1953
brass
72'' wide
Collection of the artist
Twenty-Four Lines, 1968
stainless steel
96 x 36 x 36''
Collection of the artist

KAY ROSEN
Stairwalking: Directions/Rhythms, 1981
India ink and colored pencil on paper
4 panels, 21½ x 28¼'' each
Courtesy Bertha Urdang Gallery, New York
Lines: Queue, 1982
typeset text and china marker on mylar overlay
32 x 40 x 2''
Courtesy Bertha Urdang Gallery, New York
Lines: Balloons, Clouds and Bubbles, 1982
typeset text and china marker on mylar overlay
32 x 40 x 2''
Courtesy Bertha Urdang Gallery, New York

TOM SHELTON
Swimmers, 1981
acrylic on canvas
72 x 54½''
Courtesy of the artist
Islands, 1982
oil on canvas
48 x 71½''
Courtesy of the artist

HOLLIS SIGLER
No Longer Dreaming, 1983
oil on canvas
50½ x 62''
Courtesy Barbara Gladstone Gallery, New York
She's Always Looking for Love, 1982
oil on canvas
49½ x 61''
Courtesy Dart Gallery, Chicago and Barbara Gladstone Gallery, New York

DAVID SMITH
Circle V (Circle: Black, White and Tan), 1963
painted steel
77 x 92 x 20''
Collection The First National Bank of Chicago
Cockfight – Variation, 1945
steel
34 x 13¾ x 6''
Collection Whitney Museum of American Art, New York: Purchase 1946.46.9
Untitled (gestural sculpture), 1937
oil on canvas
26⅞ x 34¹⁵/₁₆''
Collection Candida and Rebecca Smith, New York

KEVIN TEARE
Motorcade Route with Pillbox Hat, 1982
oil and wax on paper
82 x 60''
Courtesy of the artist
Mystery Takes a Walk, 1982
oil and wax on paper
60 x 60''
Courtesy of the artist

WILLIAM T. WILEY
Boo Dada Bar BQ, 1982
wood, brass, steel and paint
53 x 33 x 33''
Courtesy Allan Frumkin Gallery, New York

TOM YOUNG
The Bear, 1982
polyurethane on canvas
39 x 57''
Courtesy of the artist
Big Red, 1981
polyurethane on canvas
89 x 73''
Courtesy of the artist

George Deem
FRAMES, 1982
Oil on canvas, 50 × 50 in.
Sid Deutsch Gallery

COLOPHON

With this catalog, the Fort Wayne Museum of Art initiates its publication series, and celebrates its inaugural exhibition INDIANA INFLUENCE, showing from 8 April to 24 June 1984 at the new museum on 311 East Main Street, Fort Wayne, Indiana. From an edition of three thousand, this book is copy number:

0028

Lincoln Printing Corporation, Fort Wayne, Indiana printed this catalog. Paper for the text is Karma 80 lb. Natural, printed in eight signatures on a Miehle 38 offset press. Karma Natural paper is used because its warm color imitates the natural or incandescent lighting under which paintings and sculptures are usually seen. The cover stock is Curtis Linen: Belgium Blue Cover, Basis 130 and is perfect bound and stitched.
Alexander's Typesetting of Fort Wayne composed the text on a Merganthaler V.I.P. Typeface for the text is Goudy Oldstyle and Goudy Oldstyle Italic; for the heads and titles, Friz Quadrata. Lincoln Lithographic Services Incorporated, Fort Wayne, provided all separations and mechanicals.
Eric R. Kuhne & Associates of Princeton, New Jersey designed this catalog.